HAWAIIAN LEI MAKING
STEP-BY-STEP GUIDE

By Laurie Shimizu Ide

Mutual Publishing

First Printing October, 1998
Second Printing, March 1999
Third Printing, August 1999
Fourth Printing, April 2000
Fifth Printing, November 2000
Sixth Printing, February 2002
6 7 8 9

Softcover
ISBN 1-56647-223-7

Mutual Publishing
1215 Center Street, Suite 210
Honolulu, Hawaii 96816
Telephone (808) 732-1709
Fax (808) 734-4094
e-mail: mutual@lava.net
www.mutualpublishing.com

Printed in Korea

Mahalo Nui Loa Me Ke Aloha

(Thank You Very Much, With Love)

I am deeply grateful to the following individuals
who unselfishly gave their time, energy and
knowledge to make this book possible:

Toshi and Ethel Shimizu

Barney Bareng

Elaine Mezurashi

Michele Nagafuchi

Heidi Leianuenue Bornhorst

Special appreciation to my husband,
Karl, for his patience, support,
and technical advice.

Table of Contents

Author's Preface

There are many ways to string a lei.
No one way is the "correct" way.
Each individual must discover what
feels and looks best.

The quantities of blossoms listed may vary
depending on the size of the blossoms.

The lei life listed is based on
the average life of the lei.

A lei is to be worn,

adored by eyes,

and cherished in hearts.

The Origin of the Lei

Throughout the history of ancient Hawai'i, men and women wore bone, shell, feather, hair, and stone garlands to beautify themselves and to distinguish themselves from others. They also used decorative foliage, seeds, fruit, and colorful flowers — now known in Hawai'i as a "lei."

In modern times, the lei has become a symbol of Hawai'i — one that expresses "Aloha" or love, friendship, and affection.

The art of lei making in Hawai'i has changed with each new innovative idea. A lei may also be made with man-made materials, such as paper, ribbon, fabric, candy, currency, and even golf balls.

This *Hawaiian Lei Making Step-By-Step Guide* shows the beautiful and exotic flowers, vines, fruits, cones, and leaves used in creating traditional Hawaiian leis and also illustrates the various lei making techniques.

Lei Customs

oday in Hawai'i, the lei is traditionally presented around the head and on the shoulders of a special someone. This custom began with the Hawaiian cultural value that the head and shoulders are sacred parts of the body. The lei is worn gracefully over the shoulders draped both in the front as well as in the back. However, there are no "rules" written in today's modern society.

Almost any type of lei may be given to anyone as a token or gift of friendship. Presenting someone with a lei represents the admiration, respect, and honor given toward the individual. The lei is also given for special occasions and celebrations such as birthdays, graduations, anniversaries, weddings, and all special moments in one's life. The lei may even be made or bought for oneself to wear.

The placement of the lei is traditionally followed by a kiss which represents love, a wish of luck or *"Aloha."* This custom is now universally known as the "Hawaiian Lei Custom."

Back in the Boat Days in the late 1800s and early 1900s, visitors who arrived or departed on the steamships from the Hawaiian Islands each received a lei as a gift of *aloha*. It is said that many departing visitors would throw their lei into the sea as the ship passed Diamond Head in hopes of the lei floating back to the beaches of the Islands. This would signify that he or she would also return to the Islands someday.

Today, the giving of a lei to someone who is departing or arriving to the Islands continues, but the lei is often kept as a memento of its beauty, fragrance, and for those special memories of *"Aloha."*

Ni'ihau

"The Kapu Isle"

Pupu Shells
Momi: *Euplica varians*
Laiki: *Mitrella margarita*
Kahelelani: *Leptothyra verruca*

Kaua'i

"The Garden Isle"

Mokihana: *Pelea anisata*

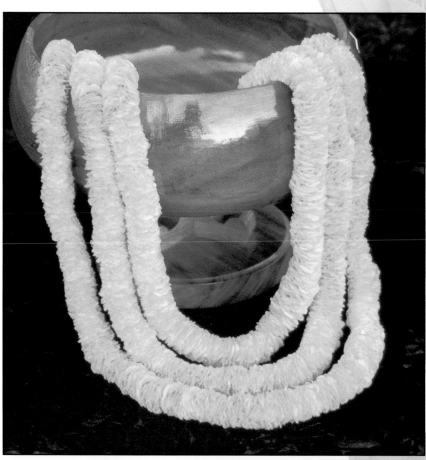

O'ahu
"The Gathering Place"

'Ilima: *Sida fallax*

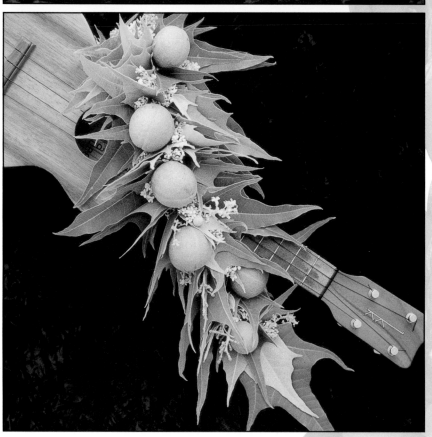

Moloka'i
"The Friendly Isle"

Kukui or Candlenut: *Aleurites moluccana*

Lana'i

"The Secluded Isle"

Kauna'oa Kahakai **or Hawaiian Dodder:** *Cuscuta sandwichiana*

Maui

"The Valley Isle"

Lokelani: *Rosa chinesis*

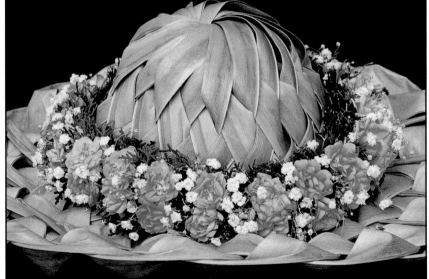

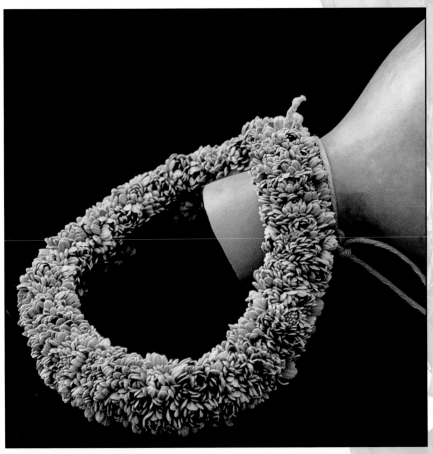

Kaho'olawe
"The Barren Isle"

Hinahina Kū Kahakai
Heliotropium anomalum var.
argenteum

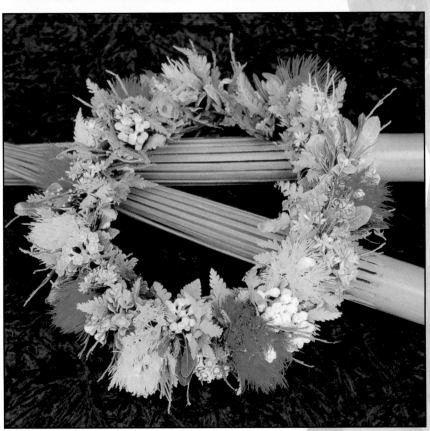

Hawai'i
"The Orchid Isle" or
"The Big Isle"

'Ohi'a Lehua
Metrosideros collina
subsp. polymorphia

Six Lei Making Methods

1. *Kui* - stringing

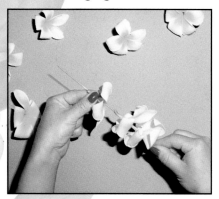

a. *Kui Pololei*—
straight, single pattern

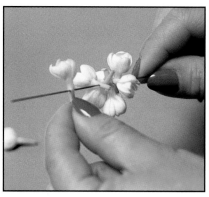

b. *Kui Poepoe*—
circular, double pattern

c. *Kui Lau*—
back-and-forth pattern

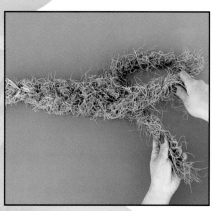

2. *Hili* or *Hilo*—
braiding, weaving pattern

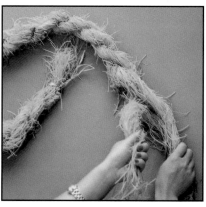

3. *Wili*—
twining, twisting pattern

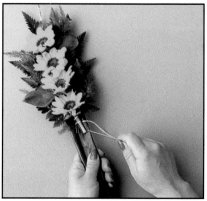

4. *Humu Humu Papa* or
***Humupapa*—sewing with a needle**
and thread

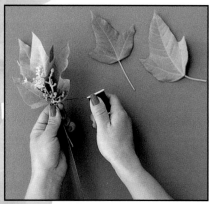

5. *Haku*— setting or mounting
against a background material

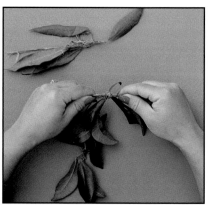

6. *Kipuu, Hipuu, Nipuu*—tying
together, knotted pattern

Lei Making Needles

modern addition to the art of lei making, metal needles have greatly expanded what types of leis could be made. The ancient Hawaiians had no metals, thus no needles.

A long, stainless steel needle (often made in Hawai‘i) can be found at a florist or craft center.

This special needle is sharpened to a point at one end, while the other end is bent to a flat "eye" to hook on the thread. After threading, this "eye" must be flat so that blossoms can slide over it smoothly, preventing breakage.

The needles used in lei making vary in length and thickness. They range from 3 to 14 inches in length, and are available in thin, medium, and thick grades.

The most common stainless steel needle used for stringing leis is the 12-inch long, medium grade needle.

'Akulikuli

Translation: Succulent • Common Name: Ice Plant or Noon Flower • Scientific Name: *Lamprantus glomeratus* **(shining flower with a rounded cluster shape) • Family Name: Carpetweed (Aizoaceae)**

Description: A low vining ground cover plant with blossoms ranging from white to pink, red, yellow, and orange; spiky blossoms about 1" long and 2" wide, containing numerous fine petals and stamens; no fragrance.

Characteristics: Flowers open at around noon in sunshine and close in the evening. Two to four days lei life.

Climate/Location: Tropical climate, near salt marshes or brackish water, usually in low laying areas near the shore. Direct sunlight. Found in abundance in Waimea, Big Island of Hawai'i, and in Ho'olehua, Maui.

Season/Harvest Period: Year-round, abundant April to October. Pick buds early in the morning. Keep out of water to preserve soft pliable stems. String blossoms in the bud stage. To blossom, leave lei out of the refrigerator for about 2 hours. The blossoms will bloom and interlace, creating a full lei.

Storage: Keep dry and airtight. Wrap in dry tissue or paper towel. Place in plastic bag or container. Refrigerate.

Materials: Medium, 12" lei needle; 104" length, 3-ply lei twine or #10 crochet thread; folded in half. Tie a double knot about 6" from open end of the string. Hook on the lei needle.

Quantity: 250 blossoms, strung by fours for a 40" double lei, *kui poepoe,* circular pattern; 500-520 blossoms, strung by fours for a 40" half-circular double lei, *kui poepoe,* circular pattern.

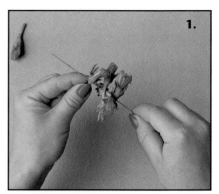

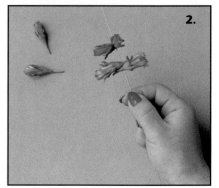

'*Akulikuli* **plants**

1. Pierce about 20 blossoms, placing 4 in a circular pattern. Gently hold blossoms and pull down to the knotted end of the string. Continue until 40" in length.

2. Pierce 4 blossoms in a double "V" pattern for a half-double lei. Add 4 consecutive blossoms in the "V" pattern for each layer. Gently hold blossoms and pull down to the knotted end of the string. Continue until 40" in length.

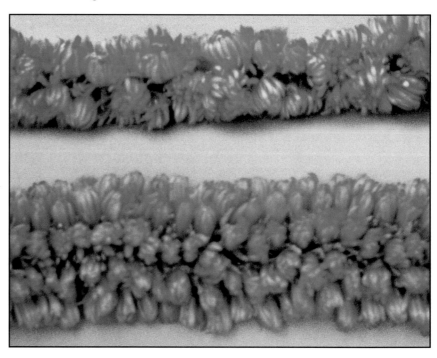

'*Akulikuli* **leis:** *kui poepoe,* **double lei, circular pattern (top);** *kui poepoe,* **half-double lei, half-circular pattern (bottom).**

Aloalo Huamoa or Aloalo Pele

Translation: Egg Hibiscus or Bell Hibiscus • **English/Common Name:** Lantern Ilima, Bell Ilima or Egg Ilima
Scientific Name: *Abutilon pictum* (flowering maple, brightly painted) • **Family Name:** Hibiscus *(Malvaceae)*

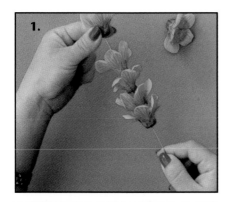

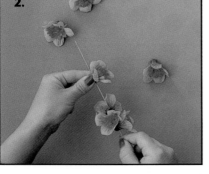

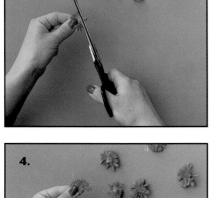

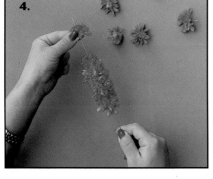

Aloalo Huamoa **plant**

1. Pierce 5 blossoms for a single lei. Gently hold blossoms and pull down to the knotted end of the string. Continue until lei is 40" long.

2. For a double lei, pierce 9 blossoms, sewing 3 around in a circular pattern. Gently hold blossoms and pull down to the knotted end of the string. Continue until the lei is 40" long.

3. Pinch off the calyx. Pluck off the petals for a stamen lei. Cut off 1/8" to prepare for piercing.

4. Pierce about 15 blossoms in a straight pattern. Gently hold blossoms and pull down to knotted end of string. Continue until 40" in length.

Description: A shrub having bell-shaped, yellow-orange with red veins, 1" long blossoms with a bright red center; no fragrance.

Characteristics: Durable and fairly long-lasting. Two to three days lei life.

Climate/Location: Warm climate, backyard cultivation, direct sunlight.

Season/Harvest Period: Year-round, peaks in the summer. Pick when blossoms are fully opened or half opened. Blossoms will open as you string them.

Storage: Keep dry. Place in plastic bag or container. Refrigerate.

Materials: Medium, 12" lei needle; 104" length, 3-ply lei twine or #10 crochet thread, folded in half for a single or double lei. Tie a double knot about 6" from the open end of the string. 52" length twine for a stamen lei. Hook on the lei needle.

Quantity: 70-75 blossoms for a 40" single lei, *kui pololei*, straight pattern; 100-120 blossoms for a 40" double lei, *kui poepoe*, circular pattern; 270 blossoms, for a 40" stamen single lei, *kui pololei*, straight pattern

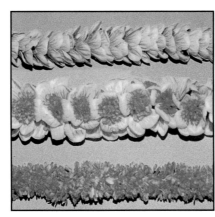

Aloalo Huamoa **leis:** *kui pololei*, **straight single pattern (top);** *kui poepoe*, **circular double pattern (middle); and** *kui pololei*, **stamen, straight single pattern (bottom).**

Aloalo 'Ilima Papa

Translation: Forbidden Hibiscus • Common Name: Royal 'Ilima or 'Ilima
Scientific Name: *Sida fallax* **(water plant, deceptive) • Family Name: Hibiscus** *(Malvaceae)*

Description: A shrub having delicate, tissue paper-like flowers, yellow to deep gold in color, one inch in diameter with five petals; no fragrance.

Characteristics: Flower of O'ahu; lei of royalty; fragile; one day lei life.

Climate/Location: Warm climate, backyard cultivation; low elevation; direct sunlight.

Season/Harvest Period: Year-round, peaking in the Summer. To prevent bruising, pick in bud form before sunrise, no later than early mid-morning. Flowers open to full bloom by noon.

Storage: Keep dry and airtight. Wrap in dry tissue or a paper towel. Place in a plastic container or bag. Refrigerate.

Materials: Thin or medium, 8" lei needle; 52" length, carpet thread; glace finish, cotton covered polyester. Tie a double knot about 6" from one end of the string. Hook on the lei needle.

Miscellaneous: Porous, one-inch thick styrofoam sheet.

Quantity: 650-700 blossoms for a 40" single, *kui pololei,* straight pattern.

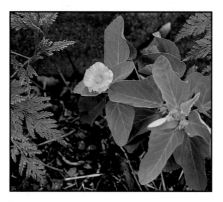

Aloalo 'Ilima Papa **plant**

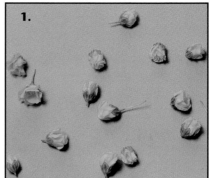

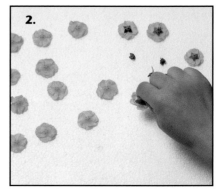

1. Pick blossoms in the bud stage. Let sit for 2 hours for blossoms to open.

2. Pinch off calyx. Place blossoms face down on the styrofoam sheet.

3. Pierce about 15 blossoms using a styrofoam sheet as a base. Gently hold blossoms and pull down to knotted end of string. Continue until 40" in length.

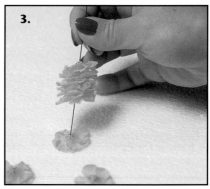

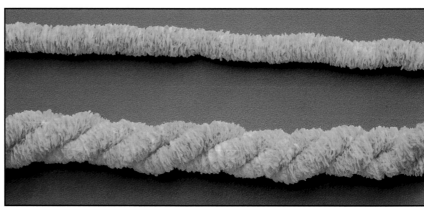

Aloalo 'Ilima Papa **leis:** *kui pololei,* **straight, single pattern (top);** *kui pololei wili,* **straight single pattern, twisting 2 strands (bottom).**

Aloalo Ma'o

**Translation: Green Hibiscus • Common Name: Royal 'Ilima • Scientific Name: *Abutilon molle grandifolium*
(flowering maple, sweet and big) • Family Name: Hibiscus (*Malvaceae*)**

An *Aloalo Ma'o* plant

1. Pinch off stems.

2. Pierce about 5 blossoms.

3. Gently hold the blossoms and pull down to the knotted end of the string.

4. Continue until the lei is 40" in length.

Description: A shrub having light orange, crepe, 1" in diameter, delicate, paper-like double-petaled blossom with a large green calyx; no fragrance.

Characteristics: One day lei life.

Climate/Location: Warm climate, backyard cultivation; low elevation; direct sunlight.

Season/Harvest Period: Year-round, peaking in the Summer. Pick when fully blossomed in the mid-morning through early afternoon. Flowers are best when picked fully opened.

Storage: Keep dry and airtight. Wrap in dry tissue or a paper towel. Place in a plastic bag or container. Refrigerate.

Materials: Medium, 12" lei needle; 52" length, carpet thread, glace finish, cotton covered polyester. Tie a double knot about 6" from one end of the string. Hook on the lei needle.

Quantity: about 130 blossoms for a 40" single lei, *kui pololei,* straight pattern.

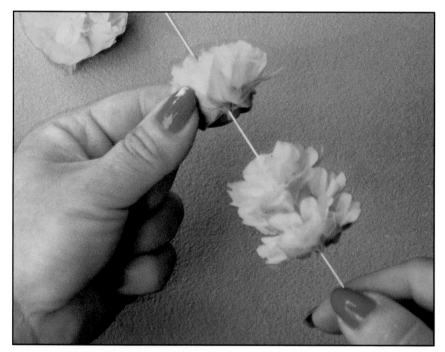

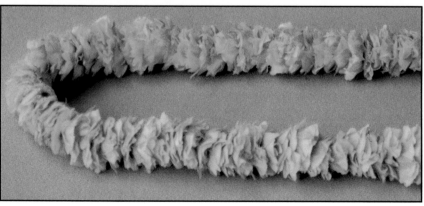

***Aloalo Ma'o* lei: *kui pololei,* single lei, straight pattern.**

Aloalo Pahūpahū

Translation: Firecracker Hibiscus • Common Name: Turk's Cap, Firecracker Hibiscus, or Lei Hibiscus • Scientific Name: *Malvaviscus arboreus var.penduliflorus* **(mallow glue, woody growing in tree-like form, hanging) • Family Name: Hibiscus (Malvaceae)**

Description: A shrub having firecracker red 2" to 2-1/2" long pendant blossoms, which do not open; protruding stamens; no fragrance.

Characteristics: Bright red, eye-catching color. One day lei life.

Climate/Location: Warm climate, tropical region, backyard cultivation, direct sunlight.

Season/Harvest Period: Year-round, low in December through February. Pick when mature in size, before blossoms "loosen" open.

Storage: Keep dry and airtight. Roll or fold into a ball. Wrap in wax paper. Refrigerate.

Materials: 160" yarn or plastic wrapping twine for the Micronesian-style lei.

Miscellaneous: Tape.

Quantity: 90 blossoms for a 40" Micronesian-style lei, flat lei weaving pattern.

An *Aloalo Pahupahu* blossom

1. Cut three pieces of yarn, two at 40" and one at 80" long. Tie and knot 6" from one end, combining three pieces together. Tape to table. Tape yarn A and B to table. Place yarn C below A and B for the starting position. Place first blossom under yarn A and over yarn B and C.

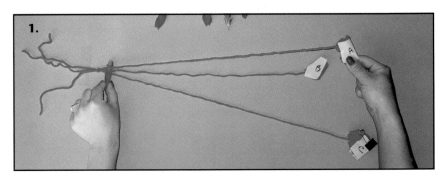

2. Bring yarn C over A and B.

3. Bring yarn C back down and under yarn A and B into the loop. Pull yarn C up and to the left to secure the blossom. Bring yarn C back to the starting position. Continue to add blossoms until 40" is completed.

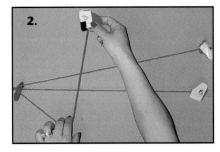

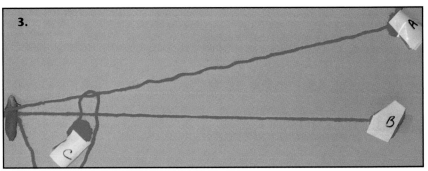

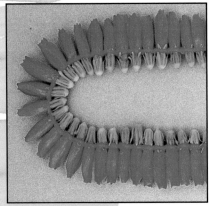

Aloalo Pahupahu **lei: Micronesian style, flat lei, weaving pattern.**

'Awapuhi-Ke'oke'o

Translation: White Ginger • Common Name: White Ginger
Scientific Name: *Hedychium coronarium* (ginger-lily for garlands) • Family Name: Ginger (*Zingiberaceae*)

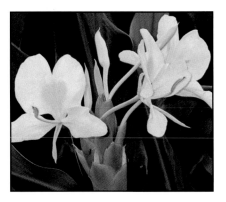

An *'Awapuhi-ke'oke'o* plant

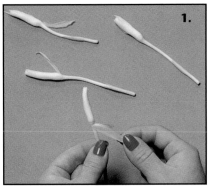

Description: A leaf stalk bearing white blossoms; 3" diameter; fragrant; shaped like a moth; 1.5" long with a broad lip at the top and a pair of side petals.

Characteristics: One day lei life. The fragrance lasts for two days.

Climate/Location: Warm to cool climate; grows wild along streams and damp, cool roadsides and forests; backyard cultivation; direct sunlight.

Season/Harvest Period: Year-round, peaking late Spring to late Fall.

Kui pololei—Single, straight pattern. Pick blossoms in bud form early in morning. Rinse off any insect pests. Gently shake off excess water. Place buds in water to open.

Micronesian—Braiding or weaving pattern. Pick blossoms as buds. Rinse off any insect pests. Gently shake off excess water. Do not place in water, keep in bud form. Wrap in a Ti leaf. Place in cellophane wrap; keep airtight. Refrigerate. Buds may be stored several days until enough blossoms are gathered.

Kui poepoe—Circular double pattern. Pick blossoms as buds or half open early in morning. Place stems in water.

Storage: Sprinkle lightly. Place in a plastic bag or container. The Micronesian style lei may be rolled into a ball. Keep dry and airtight in plastic wrap. Refrigerate.

Materials: Medium, 12" lei needle; 104" length, 3-ply lei twine or #10 crochet thread, folded in half, for a single or double lei. Tie a double knot about 6" from open end of the string. Hook on the lei needle. Twine: 2-75" string, yarn or plastic packing twine for Micronesian lei, braiding, weaving style. Tape.

1. Pick blossoms in bud form. Peel off skin (sepals). Gently open up blossoms. Pinch off stems leaving 1".

2. Gently open blossoms. Pierce about 5 blossoms for a single lei. Gently hold blossoms and pull down to knotted end of the string. Continue until 40" in length.

3. Pierce about 15 blossoms, sewing 3 around in a circular pattern for a double lei. Gently hold blossoms and pull down to knotted end of the string. Continue until a 40" length is completed.

4. Peel off green covering from the base of the stem for a Micronesian lei. Leave the bud covering on until lei is completed, keeping blossoms from opening. Cut two 75" nylon twine strips. Tie a knot 6" from one end. Tape onto table. Place the first blossom.

continued on following page

Quantity: 70-80 blossoms for a 40" single lei, *kui pololei*, straight pattern; 110-120 blossoms for a 40" Micronesian lei, braiding, weaving pattern; 335-350 blossoms for 40" double lei, *kui poepoe*, circular pattern, 3 blossoms circular if open flowers, 5 blossoms circular if half-open flowers.

5. Blossom should be between twine. Twist the twine one full turn to secure the blossom.

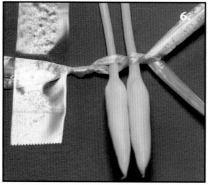

6. Add blossom #2. Make a full twist.

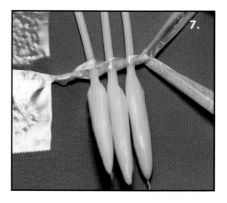

7. Add blossom #3. Make a full twist.

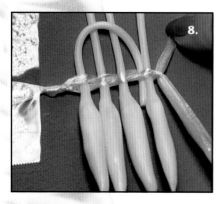

8. Take stem of blossom #1 and place it with blossom #4, creating a scallop design. Make a full twist to secure.

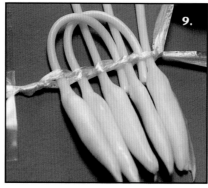

9. Add stem #2 and blossom #5, twist. Continue until 40" long.

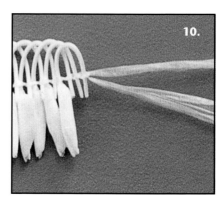

10. Scallop the last 3 stems one at a time by twisting between each stem. Tie a knot to end.

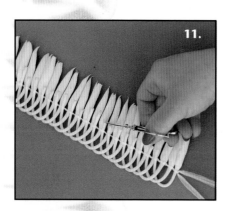

11. Trim ends of stems uniformly.

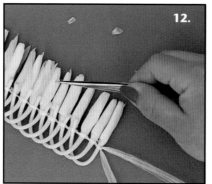

12. Remove sepals from blossoms by lightly misting the lei and removing sepals with tweezers or fingers.

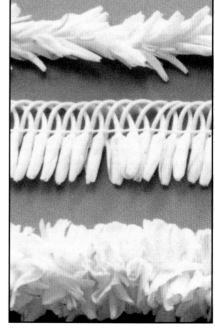

'Awapuhi-Ke'oke'o leis: *kui pololei*, **single lei, straight pattern (top)**
Micronesian, flat, braiding or weaving pattern (middle) *kui poepoe*,
double lei, circular pattern (bottom)

Hala

**Translation: To pass, a new beginning or fault • Common Name: Screw Pine, Walking Tree, or Pineapple Tree
Scientific Name: *Pandanus odoratissimus* (screw-pine, fragrant) • Family Name: Screw Pine *(Pandanaceae)***

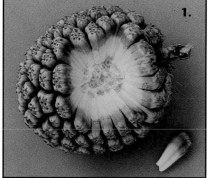

The *Hala* fruit

1. Open fruit when it is light green to light yellow, using a hammer and chisel. Break off the keys.

2. Cut keys 3/4" from the base using a shears, razor or X-acto knife. Trim off the bottom 1/8" making a straight cut.

3. Cut keys with an X-acto knife for a fancy flower pattern. The cut should not be deeper than the mid-point of the key. This indentation creates a snug fit for the following key.

4. Pierce about 4 keys starting at the base end. Grasp all keys and pull down to knotted end of the string. Continue until 40" long.

5. Pierce about 5 keys. Grasp all keys and pull down to knotted end of the string. Continue until lei is 40" in length.

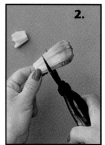

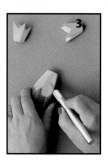

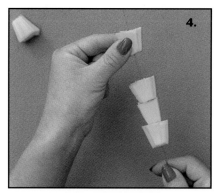

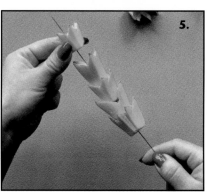

Description: A tree bearing pineapple-like fragrant fruits, 8"-10" in diameter, which turn green to yellow, orange, and then red when ripe.

Characteristics: The fruit may carry insect pests. The Federal department of Agriculture prohibits taking this fruit to the Mainland. The fruits are found only on female trees; male trees produce blossoms that were used as an aphrodisiac by ancient Hawaiians. Three to five days lei life.

Climate/Location: Warm climate, low elevation; moist coastal areas; direct sunlight.

Season/Harvest Period: Year-round. Pick fruit when it is light green to light yellow.

Storage: Keep dry. Place in plastic bag or container. Refrigerate.

Materials: Hammer, chisel, shears, X-acto knife, thick 12" needle, 104" length 3-ply twine or #10 crochet thread, folded in half. Tie a double knot about 6" from the open end of the string. Hook on the lei needle.

Quantity: Approximately 55 keys for a 40" single lei, *kui pololei*, straight pattern.

Note: According to Hawaiian custom, it is inappropriate to give this lei to politicians, or to persons starting a new business or a new project.

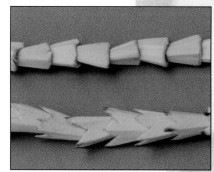

***Hala* leis: *kui pololei*, single lei, straight pattern (top); *kui pololei*, single flower cut lei, straight pattern (bottom).**

He'e

Translation: Octopus • Common Name: Octopus Tree, Umbrella Tree • Scientific Name: *Brassaia actinophylla* **(a section of the schefflera, flannel flower at the edge of leaf branches) • Family Name: Panax** *(Araliaceae)*

Description: A tree having round fruits turning pink to red to brown; located on spikes, like the arms of an octopus.

Characteristics: Durable. Seven to 10 days lei life.

Climate/Location: Tropical climate; backyard cultivation; along roadsides; in wet forests; direct sunlight.

Season/Harvest Period: Year-round, peaking April through October. Pick fruits before they blossom; pink and red seeds are favorable.

Storage: Keep dry. Wrap in newspaper. Refrigerate.

Materials: Medium, 12" lei needle, 104" length, 3-ply twine or #10 crochet thread, folded in half. Tie a double knot about 6" from the open end of the string. Hook on the lei needle.

Quantity: 75-85 fruits for a 40" single lei, *kui pololei,* straight pattern.

The *He'e* plant

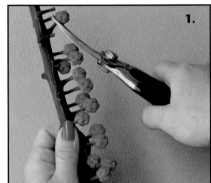

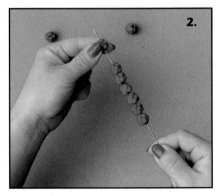

1. Cut off the fruits from the stem.

2. Pierce about 7 fruits from the base end. Hold fruits and pull down to the knotted end of the string. Continue until lei is 40" in length.

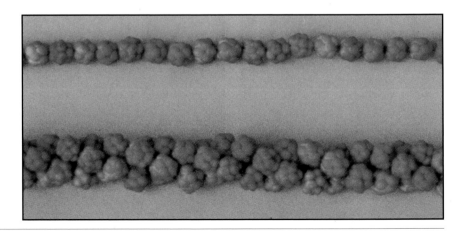

He'e leis: *kui pololei,* single lei, straight pattern (top); *kui pololei wili,* single lei, straight pattern, twisting 3 strands (bottom).

Hinahina or 'Umi 'Umi O Dole

Translation: Grayish beard or Whiskers of Mr. Dole • **Common Name:** Spanish Moss, Dole's Beard or Whiskers, Florida Moss, Pele's Hair • **Scientific Name:** *Tillandsia usneoides* (Spanish moss, resembling usnes, a lichen that looks like Spanish moss)• **Family Name:** Pineapple *(Bromeliaceae)*

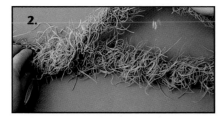

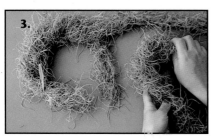

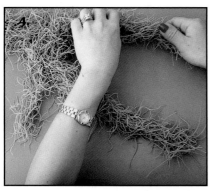

Hinahina 'Umi 'Umi O Dole moss growing on a Jabon tree

1. Tie 2 pieces together with raffia or string. Use one long and one shorter piece. Twist both strands in the same direction, to the right.

2. Twist strands around each other, left over right.

3. Lengthen as one end becomes short. Add a patch to the center of both strands with the longer end of the patch to the shorter strand.

4. Add the new patch in by twisting both strands to the right. When strands become short, add new patches. Continue to twist and add until 40" in length. Tie end with raffia or string. This lei may also be braided.

Description: Slender, grayish, thread-like moss that grows on tree branches. No fragrance.

Characteristics: Represented as a substitute for the true Hinahina of Kahoolawe, Hinahina Ku Kahakai *(Heliotropium anomalum var. argenteum). See page 13.* Fourteen days lei life.

Climate/Location: Warm climate; backyard cultivation; direct or in-direct sunlight.

Season/Harvest Period: Year-round. Harvest any time.

Storage: Store at room temperature or refrigerate.

Materials: String or raffia, 12" in length.

Quantity: Discretionable.

Hinahina 'Umi 'Umi O Dole lei: wili, **open-ended horseshoe lei, winding twisting pattern.**

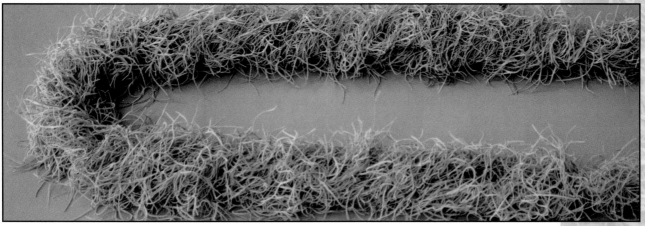

Kai Waina

Translation: Sea Grape • Common Name: Sea Grape
Scientific Name: *Coccoloba uvifera* **(seaside grape, bearing grapes) • Family Name: Buckwheat** *(Polygonaceae)*

Description: Tree bearing light green, edible, pear-shaped fruit hanging in clusters resembling grape clusters.

Characteristics: This fruit may carry microscopic insect pests. The Federal Department of Agriculture prohibits transporting this fruit lei to the Mainland. Seven days lei life.

Climate/Location: Warm climate; low elevation, near sandy shores; direct sunlight.

Season/Harvest Period: Abundant from April through November. Harvest any time.

Storage: Keep dry. Place in plastic bag or container. Refrigerate.

Materials: Carpet needle or thick, 12" lei needle; 104" length, 3-ply lei twine or #10 crochet thread, folded in half. Tie a double knot about 6" from the open end of the string. Hook on the lei needle.

Quantity: 80 fruits for a 40" single lei, *kui pololei*, straight pattern.

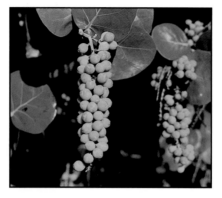

Kai Waina **fruits**

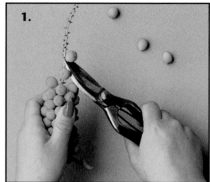

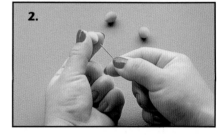

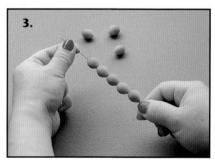

1. Cut off fruits from the bunch.

2. Pierce the needle through the fruit from the base. Be careful; the fruit is very hard.

3. Pierce about 6 fruits from the bottom. Hold fruits and pull down to the knotted end of the string. Continue until the lei is 40" in length.

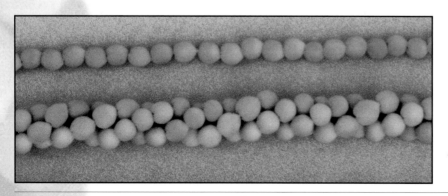

Kai Waina **leis:** *kui pololei,* **single lei, straight pattern** *(top); kui pololei wili,* **single lei, straight pattern, twisting 3 strands** *(bottom).*

Kākia

Translation: Cassia • Common Name: Candle Bush or Akapulko
Scientific Name: *Cassia alata* (senna or leguminous plants, winged) • Family Name: Bean (*Fabaceae*)

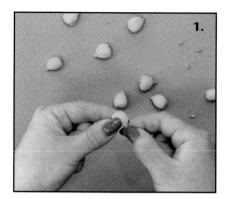

Kākia blossoms

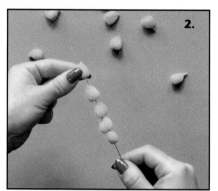

1. Pinch off stems, leaving 1/4" on blossoms.

2. Pierce about 5 blossoms, starting at the top of the blossom, for a single lei. Gently pull blossoms down to the knotted end of the string. Continue until 40" in length.

3. Pierce blossoms horizontally through the stem onto the needle in a circular pattern for a double lei. Place 3 blossoms in each layer.

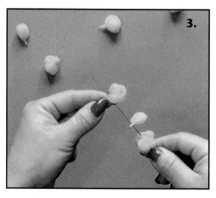

4. Pierce the next layer of blossoms in a circular pattern. Position the 3 blossoms between the first layer blossoms. Repeat circular pattern. Pierce about 25 bossoms. Gently pull blossoms down to the knotted end of the string. Continue until 40" in length.

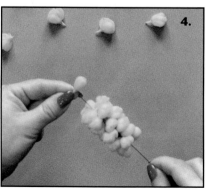

Description: A shrub with yellow, 1" flowers having 5 petals, closely packed on a spike.

Characteristics: Blossoms may carry microscopic insect pests. The Federal Department of Agriculture prohibits taking this flower to the Mainland.

Climate/Location: Tropical climate; wet lowlands; backyard cultivation; direct sunlight.

Season/Harvest Period: Late Winter through early Summer. Pick blossoms in the morning before they blossom.

Storage: Keep dry. Refrigerate.

Materials: Thin 8" lei needle; 52" length carpet thread, glace finish, cotton covered polyester. Tie a double knot about 6" from one end of the string. Hook on the lei needle.

Quantity: 70-75 blossoms for a single lei, *kui pololei*, straight pattern. 450 blossoms for a double lei, *kui poepoe*, circular pattern.

Kākia leis: *kui pololei*, single lei, straight pattern (top); *kui poepoe*, double lei, circular pattern (bottom).

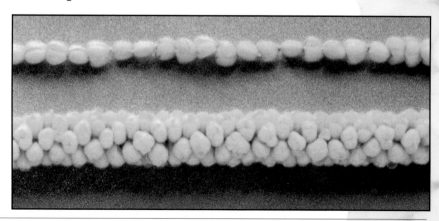

Kalaunu

Translation: Crown • Common Name: Crown Flower • Scientific Name: *Calotropis gigantea* **(beautiful ship, unusually tall or large) • Family Name: Milkweed** *(Asciepiadaceae)*

Description: A shrub having pale lavender or white blossoms, 1.5" in diameter, with 5 curled back petals around a waxy crown; light fragrance.

Characteristics: Milk sap, in large doses, is extremely toxic; remove sap from skin, preventing iritation. Versatile lei styles; 2-3 days lei life. Hint: Use hand lotion before picking and stringing so sap does not stick.

Climate/Location: Warm climate; backyard cultivation; direct sunlight.

Season/Harvest Period: Year-round, peaking in the Summer. Pick the blossoms in the early or mid-morning when cool.

Storage: Keep dry and airtight. Store in a damp newspaper. Place in a plastic bag or container. Refrigerate.

Materials: Medium, 12" lei needle; 52" 3-ply lei twine for figures 1, 3, 9, and 10. Figure 4 requires 208" twine folded in fourths; figure 5 requires 106" of twine folded in half plus 56-57 pieces for the rings. Tie a double knot about 6" from one end of the string. Hook on the lei needle.

Quantity: 60-65 blossoms for a 40" single with petal lei, *kui pololei,* straight pattern; 70-75 blossoms for a 40" single without petal lei, *kui pololei,* straight pattern; 350-400 blossoms for a large petal lei, *kui pololei,* straight pattern; 450-480 blossoms for a 40" ring lei, *kui pololei,* fancy pattern; 225 lavender blossoms, and 225 white blossoms for a 40 ring and blossom lei, *kui pololei,* straight, fancy pattern; 160 blossoms for a 40" double, 1/2 crown, rick-rack lei, *kui poepoe,* circular pattern; 184 blossoms for a 40" double 1/5 crown, rick-rack lei, *kui poepoe,* circular pattern.

A Kalaunu plant

1. Pinch off the stems for a single lei with petals. Pierce about 6 blossoms. Gently hold the blossoms and pull down to the knotted end of the string. Continue until the lei is 40" in length.

2. Break off the crown tops from the blossoms for a single lei without petals.

3. Pierce about 7 crowns. Gently hold crowns and pull down to knotted end of the string. Continue until 40" in length.

4. Pierce about 20 blossoms for a straight petal lei. Gently grasp blossoms and pull down to the knotted end of the string. Continue until 40" length is completed.

5. String 60 sets of 7 lavender crowns onto a 7" thread by piercing the sides of the blossoms. Tie a square knot, creating rings (see *kui pololei,* ring lei, figure **d,** on the opposite page).

6. String 30 sets of 7 white crowns onto a 7" thread by piercing the sides of the blossoms. String 30 sets of 7 lavender crowns for a ring blossom lei.

Tie each 7" strand of thread with a square knot, creating rings (see *kui pololei,* ring and blossom lei, figure **e,** on the opposite page).

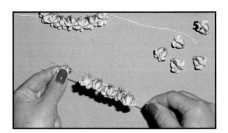

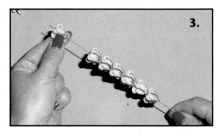
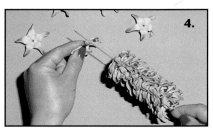
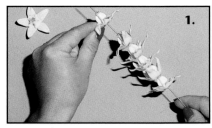
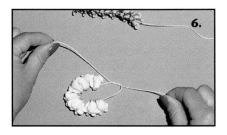

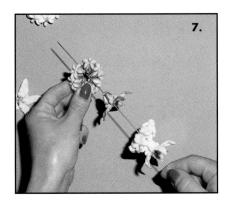

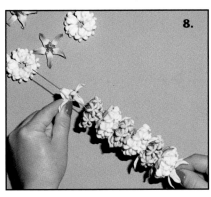

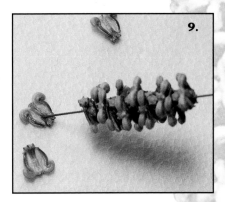

7. Pierce a white crown starting at the base end. Add a white ring, face down, followed by a lavender crown blossom, then a lavender ring, face down. Repeat the pattern for figure **e** below. For figure **d,** pull off petal of blossoms.

8. Repeat until about 6 sets are pierced. Gently hold blossoms and pull down to the knotted end of the string. Continue until 40" in length.

9. Break the crowns into halves. Discard the extra 1/5 segment. Pierce about 20 segments placing 3 in a circular pattern. Gently hold the blossoms and pull down to the knotted end of the string. Continue until lei is 40" in length.

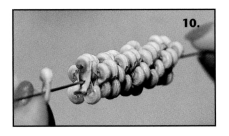

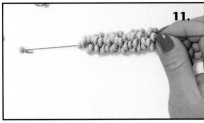

11. A styrofoam base may be used to pierce the blossom segments.

10. Break crowns into 1/5 segments. Pierce about 30 segments, placing 5 in a circular pattern. Gently hold the blossoms and pull down to the knotted end of the string. Continue until the lei is 40" in length.

Kalaunu **leis—**
a. *Kui pololei,* **single with petal lei, straight pattern**
b. *Kui pololei,* **single without petal lei, straight pattern**
c. *Kui pololei,* **petal lei, straight pattern**
d. *Kui pololei,* **ring lei, fancy pattern**
e. *Kui pololei,* **ring and blossom lei, fancy pattern**
f. *Kui poepoe,* **double, 1/2 crown, rick-rack lei, circular pattern**
g. *Kui poepoe,* **double, 1/5 crown, rick-rack lei, circular pattern**

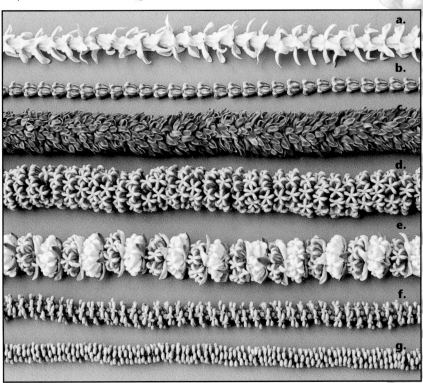

Kauhi or ʻĀwikiwiki or Maunaloa

Translation: ʻAwikiwiki - swift; Mauna-loa - sea bean • **Common Name:** True Maunaloa • **Scientific Name:** *Canavalia microcarpa* (jack-bean, small fruited) • **Family Name:** Pea Sub-family *(Papilionatae)* or Bean *(Fabaceae)*

Description: A vine having pink or lavender, 1" to 1-1/2" long, pea-like blossoms; no fragrance.

Characteristics: Seed attached to the blossoms may carry microscopic insect pests; the Federal Department of Agriculture prohibits this flower from entering the Mainland; 2-3 days lei life.

Climate/Location: Warm lowlands; backyard cultivation; direct sunlight.

Season/Harvest Period: Year-round, peaking in May through November. Pick blossoms in the early morning, before they are fully opened.

Storage: Keep dry and airtight. Place in a plastic bag or plastic container. Refrigerate.

Materials: Medium, 12" lei needle; 104" length, 3-ply lei twine or #10 crochet thread, folded in half. Tie a double knot about 6" from the open end of the string. Hook on the lei needle. Double-stick tape or carpet tape is required for a Maunaloa lei.

Quantity: 165 blossoms for a 40" flat lei, *kui lau,* back-and-forth pattern; 165 blossoms for a 40" double lei, *kui poepoe,* circular pattern.

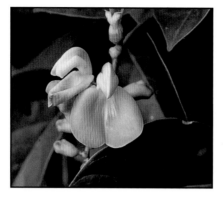

A *Kauhi* blossom

1. Pierce about 10 blossoms in a back-and-forth pattern for a flat Maunaloa lei. Gently pull down blossoms to the knotted end of the string. Continue until the lei is 40" in length.

2. Cut ten 4" pieces of double-stick, 1/4" wide tape. Place tape in a line under the tips of the blossoms and onto the calyx. Gently fold down each lip, alternating the top and bottom lips. Continue until lei is 40" in length.

3. Pierce about 12 bossoms, placing 3 in a circular pattern for a double lei. Gently hold the blossoms and pull down to the knotted end of the string. Continue until the lei is 40" in length.

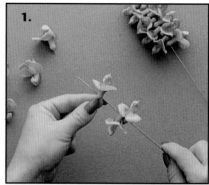

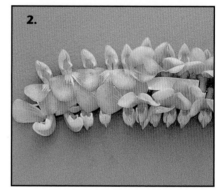

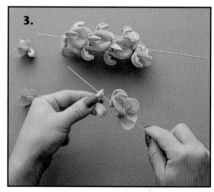

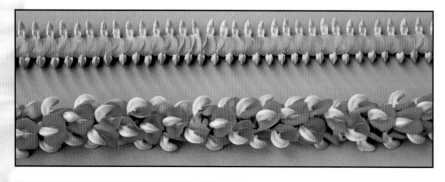

Kauhi leis: *kui lau,* flat Maunaloa lei, back-and-forth pattern (top); *kui poepoe,* double lei, circular pattern (bottom).

Kauna'oa Kahakai

Translation: Beach Orphan Vine • **Common Name:** Dodder • **Scientific Name:** *Cuscuta sandwichiana* (dodder, tangled twist of hair, from the Sandwich Islands) • **Family Name:** Morning Glory (*Convolvulaceae*)

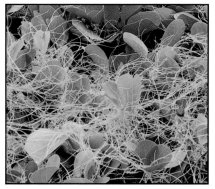

The *Kauna'oa Kahakai* vine growing with a Beach Morning Glory.

1. Soak vine in water. Gently squeeze out the water. Tie a knot to join 2 pieces. Twist both strands in the same direction, to the right.

2. Take the right strand and twine it over the left strand. Keep twining the strands over each other, to the left.

3. Create a bend at 1/3 of the add-on patch. Place it inside the twining strands. Place the longer end of the patch on the shorter side of the twining strand.

4. Twist each strand to the right. Twine right strand over left strand. Continue until lei is desired length, usually 60." This lei may also be braided.

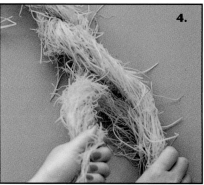

Description: A yellow-orange parasitic vine, leafless, entwining, and having tiny white blossoms; no fragrance.

Characteristics: The Kauna'oa lei represents the Island of Lana'i; 7 days lei life.

Climate/Location: Warm climate; found along roadsides, beaches, and uncultivated fields, growing and twining over plants and even up into trees; direct sunlight.

Season/Harvest Period: Year-round. Pick any time.

Storage: Do not sprinkle. Refrigerate.

Materials: String or raffia.

Quantity: Discretionable.

Kauna'oa lei: *wili,* open-ended, horseshoe lei, twisting and winding pattern.

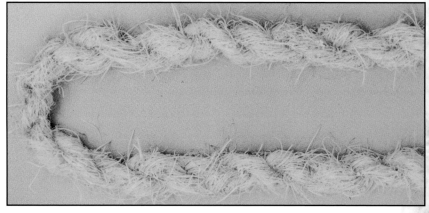

Kenikeni

Translation: Ten Cent or Dime • Common Name: Ten Cent Flower, Pua Kenikeni
Scientific Name: *Fagraca berteriana* (named after J. Th. Fagracus; named after Botonist C.G.L Bertero) • **Family Name: Strychnine** (*Loganiaceae*)

Description: A tree producing 2" long, 5-petal, white, tubular blossoms; changes to yellow, then to orange; strong perfume fragrance.

Characteristics: The flower has been called the "ten-cent flower" since the "Steamer Days" of the late 1800s and early 1900s. It is rumored that the blossoms were so prized, a Pua Kenikeni lei sold for ten cents. Three days lei life.

Climate/Location: Warm climate; backyard cultivation; direct sunlight.

Season/Harvest Period: Seasonal from April through November. Pick the blossoms in the early morning or evening when cool.

Storage: Keep dry and cool. Place in an air-filled plastic bag; float the bag with lei in a container of water; keep at room temperature; do not refrigerate.

Materials: Thick, 12" lei needle; 104" knitting yarn, folded in half, for a *kui pololei*, single lei . 104" length 3-ply lei twine or #10 crochet thread for a double lei, *kui poepoe*, circular pattern. Tie a double knot about 6" from one end of the string. Hook on the lei needle.

Quantity: 45 blossoms for a 40" single lei, kui pololei, straight pattern; 100 blossoms for a 40" double lei, *kui poepoe*, circular pattern.

A Kenikeni plant

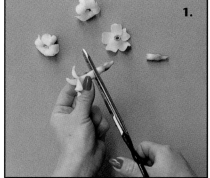

1. Cut off the calyx, leaving a 1" corolla.

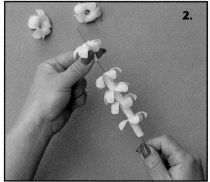

2. Pierce about five blossoms. Gently hold the blossoms and pull down to the knotted end of the string. Continue until lei is 40" in length.

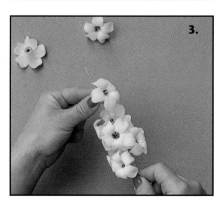

3. Cut the calyx, leaving a 3/4" corolla. Pierce about 9 blossoms, placing 3 in a circular pattern for a double lei. Gently hold the blossoms and pull down to knotted end of the string. Continue until lei is 40" in length.

Note: May also use a strip of a sheet or cotton fabric for thread in a single lei, *kui pololei*, straight pattern.

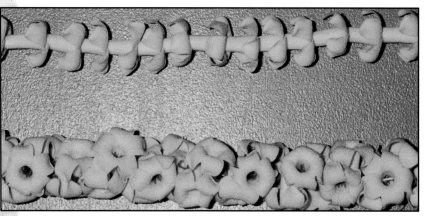

Kenikeni leis: *kui pololei,* **single lei, straight pattern (top);** *kui poepoe,* **double lei, circular pattern (bottom).**

Kepalo or Pukanawila

Translation: Devil or Bougainvillea • Common Name: Bougainvillea • Scientific Name: *Bougainvillea glabra* (named in honor of Louis Antoine de Bougainville, without hairs) • Family Name: Four O'Clock (*Nyctagineceae*)

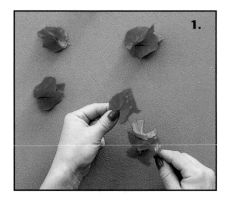

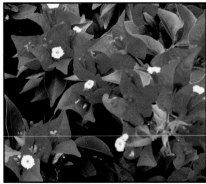

The *Kepalo* plant

1. Pierce about 12 blossoms, placing 3 in a circular pattern for a double lei. Gently hold blossoms and pull down to the knotted end of the string. Continue until 40" in length.

Description: A shrub having paper-like blossoms, 1"-2" in length, made up of three colorful modified leaves called bracts in a triangular cup form, holding three small, yellow tubular flowers; no fragrance.

Characteristics: Available in many colors; 1-3 days fresh lei life, long-lasting dried lei.

Climate/Location: Tropical, warm climate; backyard cultivation; along roadsides; direct sunlight.

Season/Harvest Period: Year-round, peaking in the summer. Pick the blossoms in the morning or evening when cool.

Storage: Sprinkle lightly. Gently shake off excess water. Place in a plastic bag or container. Refrigerate.

Materials: Medium, 12" lei needle; 104" length 3-ply lei twine or #10 crochet thread, folded in half. Tie a double knot about 6" from the open end of the string. Hook on the lei needle.

Quantity: 75 blossoms for a double lei, *kui poepoe,* circular pattern.

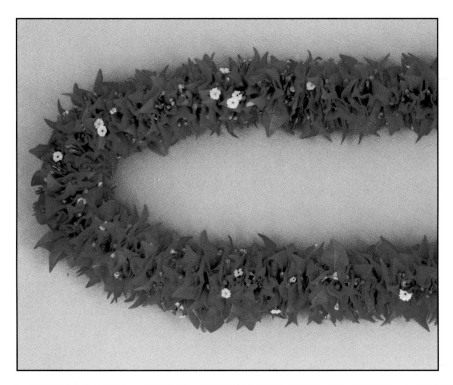

***Kepalo* lei: *kui poepoe,* double lei, circular pattern.**

Kiele

Translation: Gardenia • Common Name: Gardenia or Cape Jasmine • Scientific Name: *Gardenia jasminoides* or *Gardenia agusta* **(named after Alexander Garden, resembling jasmine) • Family Name: Coffee** *(Rubiaceae)*

Description: A shrub having white, 3" diameter blossoms with a long, tubular corolla, 5-point long winged calyx; strong fragrance.

Characteristics: The Kiele blossom attracts insect pests. The Federal department of Agriculture prohibits transporting this flower or its foliage to the Mainland. One day lei life.

Climate/Location: Warm climate, backyard cultivation; direct sunlight.

Season/Harvest Period: March through June; occasionally producing a few blossoms in fall. Pick the blossoms in the morning in the bud stage to reduce bruising. Place buds in water to open.

Storage: Sprinkle lightly. Store on wet paper towel in a bowl, unwrapped. Refrigerate.

Materials: Thick 12" needle, scissors, 104" length 3-ply twine or #10 crochet thread, folded in half. Tie a double knot about 6" from the open end of the string. Hook on the lei needle.

Quantity: 30-55 blossoms for a 40" single lei, *kui pololei*, straight pattern.

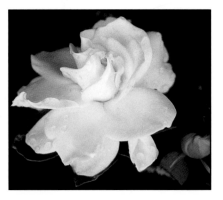

A *Kiele* **blossom • photo by Heidi Leianuenue Bornhorst**

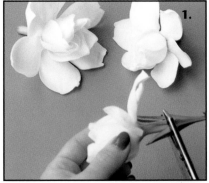

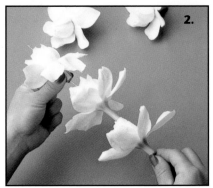

1. Cut off the calyx, leaving a 1" corolla.

2. Pierce about 3 blossoms. Gently hold blossoms and pull down to the knotted end of the string. Continue until the lei is 40" in length.

Note: May also use a strip of a sheet or cotton fabric for thread in a single lei, *kui pololei*, straight pattern.

Kiele **lei:** *kui pololei*, **single lei, straight pattern.**

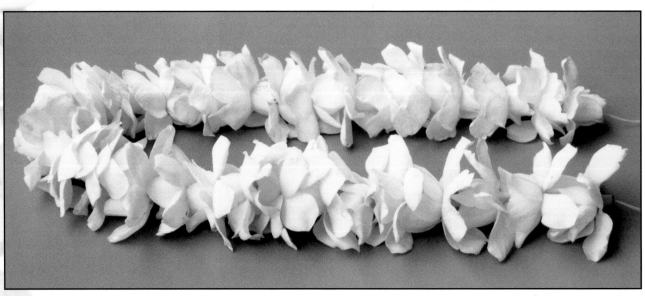

Kiele (Tiare)

**Translation: Gardenia • Common Name: Tahitian Gardenia • Scientific Name: *Gardenia taitensis*
(named after Alexander Garden, Tahitian) • Family Name: Coffee (*Rubiaceae*)**

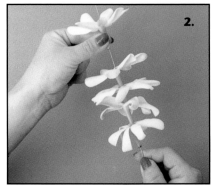

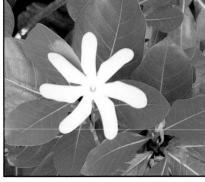

A *Kiele (Tiare)* plant

1. Cut off the calyx leaving a 1" corolla.

2. Pierce about 5 blossoms. Gently hold blossoms and pull down to the knotted end of the string. Continue until 40" in length.

Note: May also use a strip of a sheet or cotton fabric for thread in a single lei, *kui pololei,* straight pattern.

Description: A shrub having white, 3" diameter, pinwheel-like blossoms with 6-7 narrow petals and a 2" long narrow corolla; fragrant.

Characteristics: The Federal department of Agriculture prohibits taking this flower to the Mainland. One day lei life.

Climate/Location: Tropical, warm climate, backyard cultivation; direct sunlight.

Season/Harvest Period: Year-round, peaking from March through September. Pick and string blossoms in the early morning when they are half-opened, to prevent bruising.

Storage: Sprinkle. Gently shake off excess water. Place unwrapped in an open plastic container. Refrigerate.

Materials: Medium 12" needle, 104" length 3-ply twine or #10 crochet thread, folded in half. Tie a double knot about 6" from the open end of the string. Hook on the lei needle.

Quantity: 40-120 blossoms for a 40" single lei, *kui pololei,* straight pattern.

Note: 40 blossoms are needed for a single lei when the corolla is left 1" long. 120 blossoms are needed for a single lei when the corolla is 1/3" long.

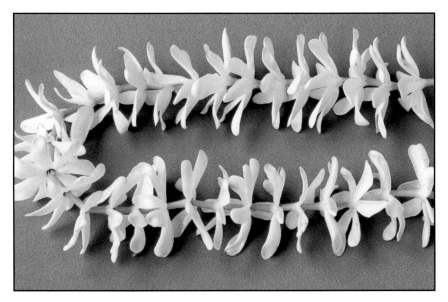

***Kiele (Tiare)* lei: *kui pololei,* single lei, straight pattern.**

Kīkā

Translation: Cigar • Common Name: Cigar • Scientific Name: *Cuphea ignea* **(curved, firey red)**
Family Name: Crape Myrtle *(Lythraceae)*

Description: A shrub having 3/4" long, tubular, slender, orange-red blossoms with black 6-tipped teeth, white speck mouth; resembles a miniature lit cigar tipped with white ash; no fragrance.

Characteristics: Very long-lasting; popular to ship to the Mainland. Up to 14 days lei life if refrigerated when not in use.

Climate/Location: Tropical, warm climate; backyard cultivation; direct sunlight.

Season/Harvest Period: Year-round; blooms in intervals throughout the year; low in the hot summer months July through August. Pick blossoms in the early morning or evening when cool. The flowers are soft during the mid-day.

Storage: Sprinkle lightly. Place in plastic bag or container. Refrigerate. May be revived by soaking in cold water in the refrigerator for 4 hours. Shake off excess water. Place in a plastic bag. Refrigerate.

Materials: Medium 12" lei needle, 104" length 3-ply twine or #10 crochet thread, folded in half. Tie a double knot about 6" from the open end of the string. Hook on the lei needle.

Quantity: 70 blossoms for a 40" single lei, *kui pololei*, straight pattern. 1800 blossoms for a 40" double lei, *kui poepoe*, circular pattern.

A *Kīkā* plant

1. Pierce about 5 blossoms, starting at the top of the blossom, for a single lei. Gently hold blossoms and pull down to the knotted end of the string. Continue until lei is 40" in length.

2. Pierce about 150 blossoms, placing 9-10 blossoms in a circular pattern. Pierce laterally through the center of the blossom, keeping the outside ends even. Place the second row of blossoms between the blossoms of the first row. Gently hold blossoms and pull down to the knotted end of the string. Continue until lei is 40" in length.

3. Pierce 5 blossoms in a half-circular pattern for a double patterned lei. Place a second layer of 5 blossoms between first layer blossoms (see diagram). Continue until about 5" is pierced. Gently hold blossoms and pull down to knotted end of string. Continue until 40" long. A spiral pattern should form naturally.

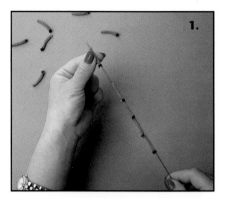

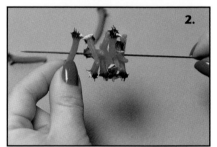

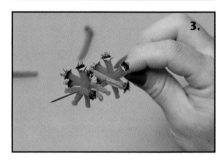

Kīkā leis: *kui pololei*, **single lei, straight pattern (top);** *kui poepoe*, **double lei, circular pattern (middle);** *kui poepoe*, **double patterned lei, circular pattern (bottom).**

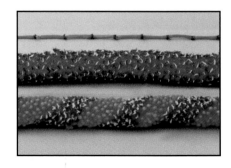

Kīkānea

Translation: Noxious Weed • Common Name: Solanum or Nightshade
Scientific Name: *Solanum aculeatissimum* (woody nightshade, very prickly) • Family Name: Tomato (*Solanaceae*)

A *Kīkānea* plant

1. Pierce about 6 fruits, piercing from the top of the fruit.

2. Grasp all fruit and pull down to the knotted end of the string. Continue until lei is 40" in length.

Description: A shrub having round, reddish-orange fruits, approximately 1" in diameter, dry, containing winged seeds.

Characteristics: The fruit is poisonous if eaten. It is fine for a lei for adults. The Federal Department of Agriculture prohibits transporting this fruit to the Mainland. Four to 7 days lei life.

Climate/Location: Warm climate, backyard cultivation; direct sunlight.

Season/Harvest Period: Year-round. Harvest when fruit is bright orange.

Storage: Keep dry. Place in plastic bag or container. Refrigerate.

Materials: Thick 12" lei needle, 104" length 3-ply twine or #10 crochet thread, folded in half. Tie a double knot about 6" from the open end of the string. Hook on the lei needle.

Quantity: Approximately 45 fruits for a 40" single lei, *kui pololei*, straight pattern.

Kīkānea lei: *kui pololei,* single lei, straight pattern.

Kukui

Translation: Lamp, light, or torch • Common Name: Kukui or Candlenut • Scientific Name: *Aleurites muluccana* (floury, dusted with flour, from Moluccas or Spice Islands of Indonesia) • Family Name: Spurge (*Euphorbiaceae*)

Description: A tree having angularly pointed, silvery, pale-green leaves with whitish down covering; small, white blossoms arranged in clusters; mild fragrance. The fruit contains a black nut when ripe, white when immature.

Characteristics: The Kukui tree is named the official tree emblem for the State of Hawaii because of the multiplicity of its uses by the ancient Hawaiians for light, fuel, medicine, and dye. The leaf lei has a 2-4 day lei life. The nut lei (not shown) has a ever-lasting lei life. The leaves and flowers represent the Island of Moloka'i.

Climate/Location: Tropical, warm climate, at lower mountain elevation; direct sunlight.

Season/Harvest Period: Blossoms year-round. Pick the leaves and blossoms during cool morning or evening hours.

Storage: Sprinkle lightly. Place in plastic bag or container. Refrigerate.

Materials: One roll carpet thread; one foot thin string.

Quantity: One 36" Hala leaf; flowers discretional; nuts discretional; and about 150 small to medium size leaves for a 60" open-ended horseshoe lei, mounting and twisting pattern.

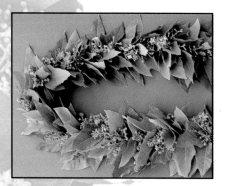

Kukui lei: Haku, wili, open-ended horseshoe lei, mounting and twining pattern.

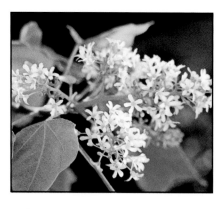

Kukui blossoms

1. Cut 2-1/4" strips off the Hala (*Pandanus veitchii*) leaf. Tie in 3 places with string to secure for a *haku* lei backing anchor.

2. Tie a thread 3" down from the Hala strip; keep thread on the spool. Prepare the leaves, blossoms, and fruit in short pieces.

3. Place a leaf about 3" from the top of a Hala strip. Tuck in 2 sides of the leaf to create body and decrease size of the leaf. Twine thread 3 times around the stem and Hala backing.

4. Place 2 leaves side by side with a flower cluster on top. Twine with thread 2 times around stem and backing. Tuck in sides of each leaf if too large. Repeat.

5. Place 2 leaves side by side with a fruit cluster on top. Twine with thread 2 times around stem and backing. Tuck in sides of each leaf if too large. Repeat.

6. Place a leaf in back of a Hala strip. Twine thread 2 times around, securing the leaf against the backing, covering the mechanics.

7. To end the lei, place 2 leaves and a flower cluster upside-down. Twine thread 2 times or more around to secure. Add additional leaves and flower clusters to fill gaps. Cut and secure thread to backing to prevent unraveling.

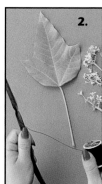
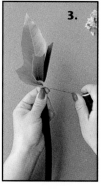
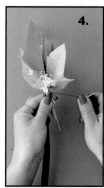
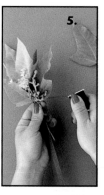
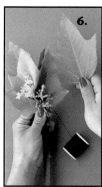
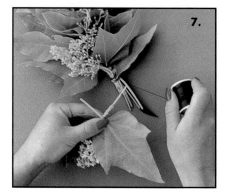

Kukuna-O-Ka-Lā

Translation: Rays of the Sun • Common Name: Oriental Mangrove • Scientific Name: *Bruguiera conjugata* **(named in honor of G. Bruguiere, joined in pairs) • Family Name: Mangrove (*Rhizophoraceae*)**

Kukuna-O-Ka-Lā **plant**

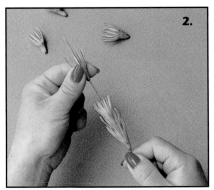

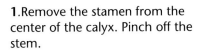

1. Remove the stamen from the center of the calyx. Pinch off the stem.

2. Pierce about 4 calyces for a single lei. Hold all calyces and pull down to the knotted end of the string. The woody core makes it difficult to pull more than four over the needle at once. Continue until lei is 40" in length.

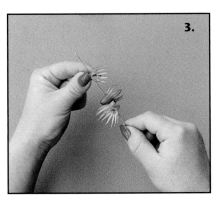

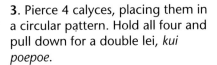

3. Pierce 4 calyces, placing them in a circular pattern. Hold all four and pull down for a double lei, *kui poepoe*.

Description: A tree having pink, yellow, or red blossoms; calyx has about 10 erect bristle lobes, longer than the petals; about 20 stamens; no fragrance.

Characteristics: The lei is made with the strong calyx of the blossoms. Ten days lei life.

Climate/Location: Warm climate; found in tropical and subtropical seacoasts and marshes, in the mouths of streams; direct sunlight.

Season/Harvest Period: Year-round. Harvest any time. Only the calyx is used for the lei.

Storage: Submerge in cold water. Gently shake off excess water. Place in a plastic bag or container. Refrigerate.

Materials: Thick 12" lei needle, 104" length 3-ply twine or #10 crochet thread, folded in half. Tie a double knot about 6" from the open end of the string. Hook on the lei needle.

Quantity: Approximately 75-85 blossoms for a 40" single lei, *kui pololei*, straight pattern; 155-170 blossoms for a double lei, *kui poepoe*, circular pattern.

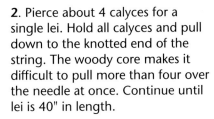

Kukuna-O-Ka-Lā **leis:** *kui pololei*, **single lei, straight pattern (top);** *kui poepoe*, **double lei, circular pattern (bottom).**

Kupaloke or Kupalo

Translation: Tuberose • Common Name: Tuberose • Scientific Name: *Polianthes tuberosa* **(grey, whitish flower, tuberous) • Family Name: Amaryllis** *(Amaryllidaceae)*

Description: A plant with grass-like leaves having 2" elongated white blossoms with spreading, oblong petals; strong fragrance.

Characteristics: Popular among visitors for its fragrance. One to 2 days lei life.

Climate/Location: Warm climate; backyard cultivation; direct sunlight.

Season/Harvest Period: Year-round, peaking February through October. Pick the fully-opened blossoms in the morning or evening when it is cool.

Storage: Keep dry. Place in paper bag. Refrigerate.

Materials: Medium 12" lei needle, 104" long, 3-ply twine or #10 crochet thread, folded in half. Tie a double knot about 6" from the open end of the string. Hook on the lei needle.

Quantity: Approximately 30-45 blossoms for a single lei, *kui pololei*, straight pattern. 150-160 blossoms for a double lei, *kui poepoe*, circular pattern.

Kupaloke **leis:** *kui pololei,* **single lei, straight pattern (top);** *kui poepoe,* **double lei, circular pattern (bottom).**

Kupaloke blossoms

1. Pinch off the calyx along with 1/4" of the corolla. The shorter the corolla, the more blossoms needed to make a 40" lei.

2. Peel off the outer damaged petals if necessary.

3. Pierce about 5 blossoms, starting at the base end, for a single lei. Gently pull the blossoms down to the knotted end of the string. Continue until lei is 40" in length.

4. Pierce about 12 blossoms, placing 3 in a circular pattern for a double lei. Gently hold the blossoms and pull down to the knotted end of the string. Continue until lei is 40" in length.

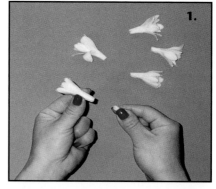

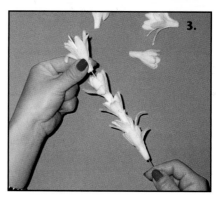

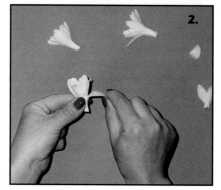

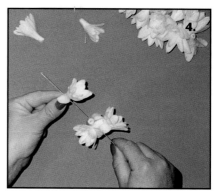

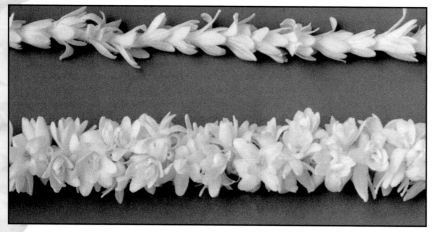

Lā'ī

Translation: Peaceful • **Common Name:** Ti Leaf or Kī Leaf
Scientific Name: *Cordyline terminalis* (a club, terminal) • **Family Name:** Lily *(Liliaceae)*

The *Ti (Kī)* plant

1. Wipe leaves. Cut out the spines of about 7 leaves. Cut the leaves into fourths, at a 45° angle. Keep one full half of a leaf. Microwave the segments for one minute, making them pliable. Or instead of microwaving them, leaves may be frozen, ironed, or dipped in hot water to soften them).

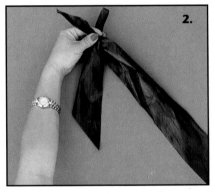

2. Tie a knot to join one long and one short leaf segment, about 1" from top.

3. Twist both sides in the same direction, to the right.

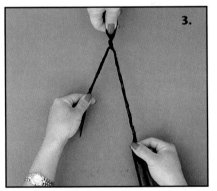

4. Twist both sides with each other evenly by always crossing the right side over the left. Lengthen by twisting in a new leaf segment, placing it 1-1/2" above the twisting point.

Continued on following page

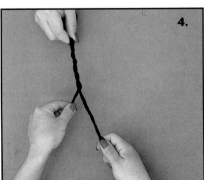

Lā'ī leis: *wili*, *Maile* style lei, winding, twisting pattern (top); *wili*, single lei, winding, twisting pattern (middle); *wili*, orchid lei, winding, twisting pattern (bottom).

Description: Narrow, oblong, smooth, shiny, flexible leaves; 1-2 feet long; approximately 4" wide, growing in a spiral cluster.

Characteristics: Plant and leaves are believed to ward off evil spirits and bring good luck. Five to 7 days lei life. Also used as a dried lei.

Climate/Location: Warm climate; backyard cultivation; direct or in-direct sunlight.

Season/Harvest Period: Year-round. Pick the mature leaves; harvest any time.

Storage: Keep dry. Wrap in newspaper. Refrigerate.

Materials: Scissors; microwave oven or iron.

Quantity: Five to 7 large leaves for a for a 50" single lei, *wili*, winding, twisting pattern; 12-13 large leaves for a 60" *Maile* style lei, wili, winding, twisting pattern; 8-10 large leaves for a 40" orchid, *wili*, winding, twisting pattern.

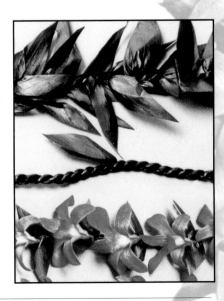

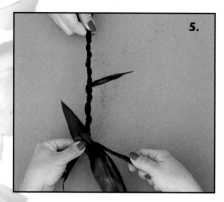 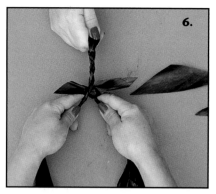 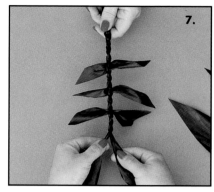

5. Twist in, with the shorter side of the lei. Keep twisting and adding until 45" in length. Tie a knot to end lei. Trim leaf points to create a leaf-like pattern.

6. Cut 14 long, full-length segments and 65 short, 5" segments, totalling 14 leaves for a Maile style lei. Tie a knot 1" from the end, joining 2 long segments. Add one small leaf segment. Twist both sides to the right. Twine both sides with each other, crossing the right side over the left. Twine 2 times. Add a leaf segment.

7. Add another small leaf segment and twist twice. Twist in the new long segments as twining leaves become short. Continue until 80" long. Knot the end.

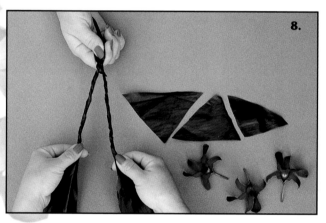 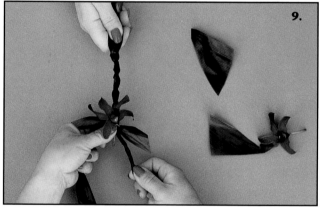

8. Cut 16 long segments and 22 short, 3" triangles totalling 10 large leaves for a *Ti* leaf orchid lei. Cut the same amount of triangles as orchids; a minimum of 8 orchids per lei is recommended. Tie a knot 1" from the end, join the 2 leaves. Twist both sides to the right. Twine both sides with each other, crossing right over left. Twine 3 times.

9. Add an orchid. Twine one, then add a leaf segment. Keep twisting both hands to the right at all times. Twine 3 times, then add an orchid. Twine once, then add a leaf segment. Continue the twisting and twining pattern until lei is 40" in length. Knot the end.

Lehua Pepa or Lei-Hua Mau Loa

Translation: Paper Lehua, Everlasting Lehua • Common Name: Globe Amaranth, Bozu, or Paper Ball
Scientific Name: *Gomphrena globosa* (globe amaranth) • Family Name: Amaranth (*Amaranthaceae*)

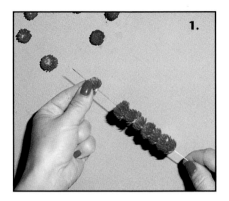

A *Lehua-Pepa* plant

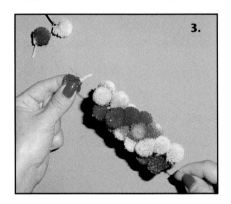

Description: A shrub having 3/4" diameter, ball-shaped, paper-like blossoms in white, red, violet, pink, or purple. Each blossom has 2 leafy bracts; no fragrance.

Characteristics: Long-lasting lei. Seven days lei life; also can be used as a dried lei.

Climate/Location: Warm climate; backyard cultivation; direct sunlight.

Season/Harvest Period: Year-round. Pick blossoms in the early morning or evening when cool.

Storage: Keep dry. Wrap in a paper towel. Refrigerate to keep fresh. To dry, do not refrigerate.

Materials: Medium 12" lei needle, 104" length 3-ply twine or #10 crochet thread, folded in half. Tie a double knot about 6" from open end of the string. Hook on the lei needle.

Quantity: 70-85 blossoms for a 40" single lei, *kui pololei*, straight pattern. 260-280 blossoms for a double lei, *kui poepoe*, circular pattern, sewing 3 in a circle.

1. Pierce about 7 blossoms for a single lei. Gently hold the blossoms and pull down to the knotted end of the string. Continue until 40" in length.

2. Pierce 3 blossoms in a circular pattern for a double lei. Pierce one of each color, if different colors are used.

3. Continue to pierce blossoms, placing 3 in a circular pattern; keep the same color rotation. Continue piercing about 24 blossoms. Gently hold the blossoms and pull down to the knotted end of the string. Continue until 40" in length.

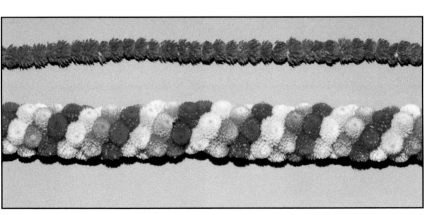

Lehua-Pepa leis: *kui pololei*, single lei, straight pattern (top); *kui poepoe*, double lei, circular pattern (bottom).

Lilia-O-Ka-Nile

Translation: Lily of the Nile • Common Name: Agapanthus, Blue Lily, African Lily, Lily of the Nile
Scientific Name: *Agapanthus umbellatus* **(lover flower, furnished with umbels) • Family Name: Lily (Liliaceae)**

Description: A plant having grass-like leaves, blue or white blossoms, with 6 oblong petals, funnel-shaped; 1"-2" long; borne on a large stalk of about 20-50 blossoms; no fragrance.

Characteristics: Rare blue color. Two to four days lei life.

Climate/Location: Tropical climate; backyard cultivation; direct sunlight.

Season/Harvest Period: April through September. Pick blossom in the early morning or evening when it is cool.

Storage: Sprinkle lightly. Place in plastic bag or container. Refrigerate.

Materials: Medium 12" lei needle, 104" length 3-ply twine or #10 crochet thread, folded in half. Tie a double knot about 6" from the open end of the string. Hook on the lei needle.

Quantity: Approximately 70-75 blossoms for a 40" single lei, *kui pololei,* straight pattern. 250-275 blossoms for a double lei, *kui poepoe,* circular pattern.

Lilia-O-Ka-Nile blossoms

1. Cut off about 1/8" of the corolla for a single lei. Do not cut the corolla for a double lei.

2. Pierce about 5 blossoms for a single lei. Gently hold the blossoms and pull down to knotted end of the string. Continue until lei is 40" in length.

3. Pierce about 20 blossoms, placing 3 in a circular pattern, for a double lei. Gently hold the blossoms and pull down to the knotted end of the string. Continue until lei is 40" in length.

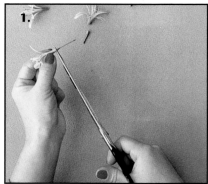

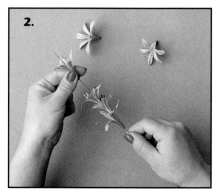

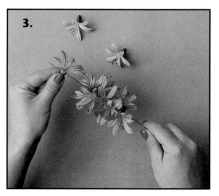

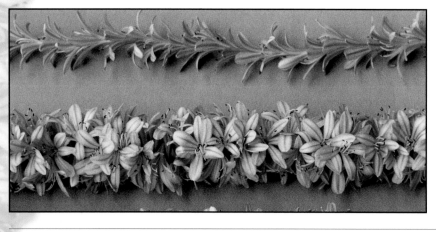

Lilia-O-Ka-Nile leis: kui pololei,
single lei, straight pattern (top);
kui poepoe, **double lei, circular**
pattern (bottom).

Lōkālia

Translation: Russelia • Common Name: Hanging Firecracker • Scientific Name: *Russelia equisetformis* **(named in honor of Dr. Alexander Russell, with leaves like horsetail) • Family Name: Snapdragon** *(Scrophulariaceae)*

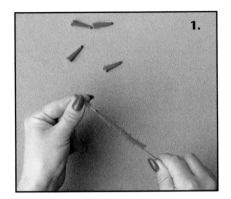

Lōkālia **blossoms**

1. Pierce about 7 blossoms for a single lei. Pierce blossoms from the top end. Gently hold the blossoms and pull down to the knotted end of the string. Continue until lei is 40" in length.

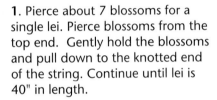

2. Use a styrofoam sheet as a base. Pierce about 50 blossoms, placing 10 in a circular pattern, for a double lei. Gently hold the blossoms and pull down to the knotted end of the string. Continue until lei is 40" in length.

Description: A shrub having bright red 1" long, tubular, nodding blossoms; no fragrance.

Characteristics: The blossoms are very fragile in a lei. One-half day lei life. However, a spray of blossoms in a vase will last about 7 days.

Climate/Location: Warm climate; backyard cultivation; direct sunlight.

Season/Harvest Period: Year-round. Pick the blossoms early in the morning while cool.

Storage: Keep dry. Wrap in tissue paper or paper towel. Place in plastic bag or container. Refrigerate.

Materials: Thin 12" lei needle, porous, one-inch thick styrofoam, 52" length carpet thread, glace finish, cotton-covered polyester. Tie a double knot about 6" from one end of the string. Hook on the lei needle.

Quantity: 140 blossoms for a single lei, *kui pololei*, straight pattern; 2,000 blossoms for a double lei, *kui poepoe*, circular pattern.

Lōkālia **leis:** *kui pololei,* **single lei, straight pattern (top),** *kui poepoe,* **double lei, circular pattern (bottom).**

Loke

Translation: Rose • Common Name: Rose, Damask Rose, or JB
Scientific Name: *Rosa damascena* (rose, from Damascus, Syria) **• Family Name: Rose** *(Rosaceae)*

Description: A bush bearing 1" long, rose buds; light fragrance when they are blossomed.

Characteristics: The leaves of the Loke blossoms may carry microscopic insect pests. The Federal Department of Agriculture prohibits this flower, with its leaves, to be taken to the Mainland. Two to 3 days lei life.

Climate/Location: Tropical, warm climate; backyard cultivation; direct sunlight.

Season/Harvest Period: Year-round, peaking in summer. Pick blossoms early in the morning when in the tight bud stage.

Storage: Keep lei in a damp paper towel. Place in plastic bag or container. Refrigerate.

Materials: Medium 12" lei needle, 104" length 3-ply lei twine or #10 crochet thread, folded in half. Tie a double knot about 6" from the open end of the string. Hook on the lei needle.

Quantity: 40 blossoms for a 40" single lei, *kui pololei*, straight pattern; 175 blossoms for a double lei, *kui poepoe*, circular pattern.

A *Loke* plant

1. Break off the stems of the blossoms.

2. Pierce about 4 blossoms for a single lei. Gently hold the blossoms and pull down to the knotted end of the string. Continue until the lei is 40" in length.

3. Pierce about 6 blossoms, placing 3 in a circular pattern, for a double lei. Gently hold the blossoms and pull down to the knotted end of the string. Continue until the lei is 40" in length.

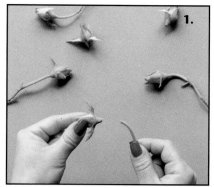

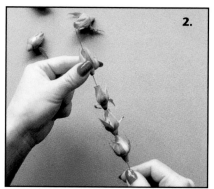

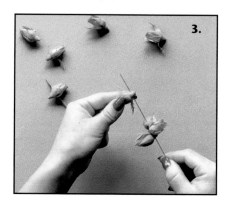

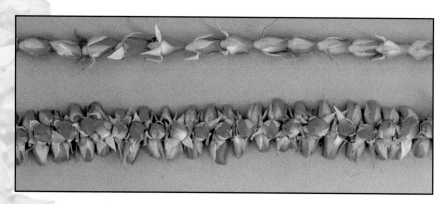

Loke **leis:** *kui pololei,* **single lei, straight pattern (top);** *kui poepoe,* **double lei, circular pattern (bottom).**

Loke-Lau

Translation: Leaf Rose • Common Name: Green Rose • Scientific Name: _Rosa chinensis var. viridiflora_ (rose, Chinese, with green flowers) • Family Name: Rose _(Rosaceae)_

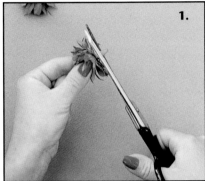

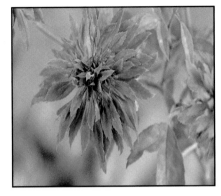

A _Loke-Lau_ blossom • Photo by Ted Takai

1. Cut off corolla, leaving 1/2" of stem.

2. Pierce about 3 blossoms for a single lei. Gently hold the blossoms and pull down to knotted end of the string. Continue until the lei is 40" in length.

Description: A shrub having green blossoms with narrow green leaves for petals, 1/2"-1" in diameter; light spicy fragrance. The flower blossoms light green and darkens as it matures.

Characteristics: This flower may carry microscopic insect pests. The Federal Department of Agriculture prohibits any part of this plant to be taken to the Mainland. Two to 3 days lei life.

Climate/Location: Warm climate; backyard cultivation; direct sunlight.

Season/Harvest Period: Year-round, low in months of December through February. Pick in full bloom.

Storage: Sprinkle lightly. Keep airtight. Place in plastic bag or container. Refrigerate.

Materials: Medium 12" lei needle, 52" length 3-ply lei twine or #10 crochet thread. Tie a double knot about 6" from the one of the string. Hook on the lei needle.

Loke-Lau lei: _kui pololei_, single lei, straight pattern.

Quantity: 60 blossoms for a 40" single lei, _kui pololei_, straight pattern.

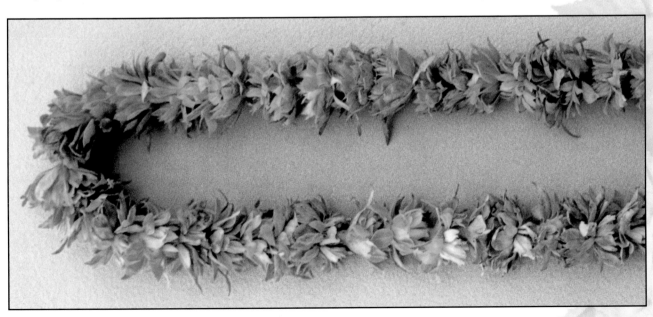

Maile

Translation: Alyxia olivaeformis • **Common Name:** Maile • **Scientific Name:** *Alyxia olivaeformis* (chain, resembling the olive) • **Family Name:** Periwinkle or Plumeria *(Apocynaceae)*

Description: A vine having oval, pointed 1"-3" long shiny leaves growing in pairs; bark and leaves have a vanilla-like fragrance.

Characteristics: A very popular open-ended horseshoe fashion lei. It is associated with Laka, Goddess of the Hula. Three to 4 days lei life.

Climate/Location: Cool climate; found in native forests, commonly on Kaua'i and Hawai'i islands; indirect sunlight.

Season/Harvest Period: Year-round. Pick when cool.

Storage: Sprinkle lightly. Wrap in newspaper. Refrigerate.

Materials: Pliers or a hammer.

Quantity: Discretionary; averaging 15 vines.

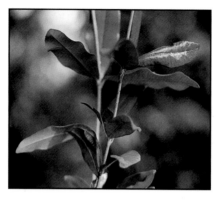

A *Maile* vine

1. Tie two ends together with a piece of bark for a wili style lei, twisting and twining pattern.

2. Add a piece to one side to lengthen and thicken the strand. Twist in to secure stem, turning to the right.

3. Add a piece to the other side to lengthen and thicken. Twist in to secure the stem, turning to the right.

4. Twine the right strand over the left. Continue until 60" long.

5. Softly pound the leaf points with a hammer or a pair of pliers for *kipuu, hipuu, nipuu,* knotted and twined lei.

6. Gently slide off bark from the core, holding the top of the shoot. Continue until enough has been stripped.

7. Tie a square knot to attach 2 pieces. Continue until 60" in length. Twine about 3-5, 60" strands together to make a lei.

Maile leis: *wili,* open-ended lei, twisting, twining method (top); *kipuu, hipuu, nipuu wili,* open-ended lei, knotted and twined method (bottom).

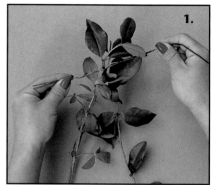

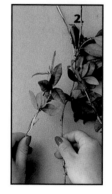
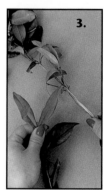

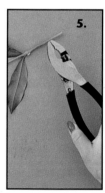

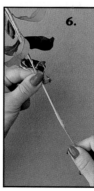
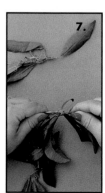

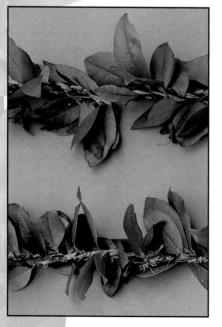

Male

Translation: Marriage or Wedding • **Common Name:** Stephanotis • **Scientific Name:** *Stephanotis floribunda* (wax flower, freeflowering) • **Family Name:** Milkweed or Crown Flower *(Asclepiadaceae)*

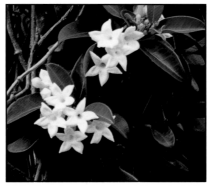

A *Male* vine

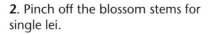

1. Cut blossoms to desired lei fullness: uncut (top left), leaving a 1/8" corolla (top right); leaving a 1/4" corolla (bottom left); leaving a 1/2" corolla (bottom right).

2. Pinch off the blossom stems for single lei.

3. Pierce about 4 blossoms for a single *Male* lei. Gently hold the blossoms and pull down to the knotted end of string. Continue until the lei is 40" in length. Also shown here is a lei needle with 1/2" corolla blossoms.

4. Cut stems, leaving 1/2" corolla. Pierce about 12 blossoms, placing 3 in a circular pattern for a double lei. Gently pull the blossoms down to the knotted end of the string. Continue until the lei is 40" in length.

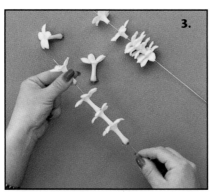

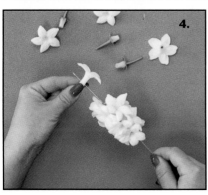

Male **leis:** *kui pololei,* **single lei, straight pattern;** *kui pololei,* **single full lei, straight pattern;** *kui poepoe,* **double lei, circular pattern**

Description: A vine having fragrant, tubular, wax-white flowers; 1"-2" long; 5 petals.

Characteristics: In Old Hawai'i, the lei was sometimes worn by brides, thus the name "Male," meaning marriage. Today, it is a favorite in wedding bouquets. Two to 3 days lei life.

Climate/Location: Warm climate; backyard cultivation; low elevation; direct sunlight.

Season/Harvest Period: March through November. Pick blossoms in the early morning or evening while cool.

Storage: Sprinkle lightly. Place in plastic bag or container. Refrigerate.

Materials: Medium 12" lei needle, 104" length carpet thread, glace finish, cotton-covered polyester folded in half; scissors. Tie a double knot about 6" from the open end of the string. Hook on the lei needle.

Quantity: 37 blossoms for a 40" single lei, *kui pololei,* straight pattern; 225 blossoms for a full single lei, *kui pololei,* straight pattern; 180 blossoms for a 40" double lei, *kui poepoe,* circular pattern.

Note: a *kui pololei* may require 25-700 blossoms, depending on how short the corolla is cut when preparing the blossoms for stringing.

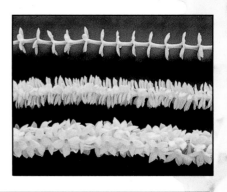

Melia

Translation: Plumeria • Common Name: Plumeria, Frangipani, or Graveyard Plumeria • Scientific Name: *Plumeria acuminata* (named for Charles Plumier, tapering into a long narrow point) • Family Name: Periwinkle *(Apocynaceae)*

Description: A tree having five-petal, white with yellow blossoms about 2" in diameter; fragrant.

Characteristics: Available in other colors. One to 2 days lei life. The milky sap is poisonous if eaten.

Climate/Location: Warm climate; backyard cultivation; low elevation; direct sunlight.

Season/Harvest Period: Dormant during the Winter. Peaking in March through November.

Storage: Sprinkle lightly. Wrap in a damp paper or cloth towel. Place in the sink or a bowl. Keep cool; do not refrigerate.

Materials: Thick 12" lei needle, 104" length 3-ply twine or #10 crochet thread, folded in half. Tie a double knot about 6" from the open end of the string. Hook on the lei needle.

Quantity: 50-60 blossoms for a 40" single lei, *kui pololei,* straight pattern; 110-120 blossoms for a 40" double lei, *kui poepoe,* circular pattern.

Note: Lubricate the needle with Vaseline petroleum jelly to keep the milky sap from accumulating on needle. Hand lotion helps to keep hands sap free.

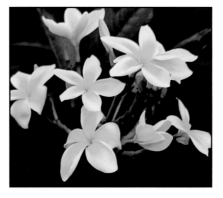

Melia **blossoms**

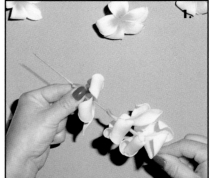

1. Pierce about 4 blossoms for a single lei. Gently hold blossoms and pull down to the knotted end of string. Continue until lei is 40" in length.

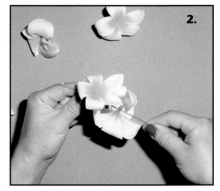

2. Pierce 3 blossoms in a circular pattern for a double lei.

3. Pierce about 9 blossoms. Gently hold blossoms and pull down to knotted end of string. Continue until 40" in length.

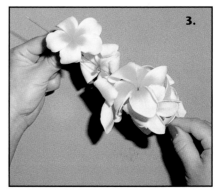

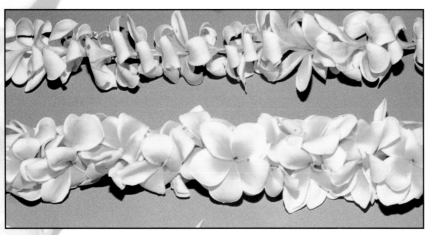

Melia leis: *kui pololei,* **single lei, straight pattern (top);** *kui poepoe,* **double lei, circular pattern (bottom).**

Mokihana

**Translation: Pelea anisata • Common Name: Mokihana • Scientific Name: *Pelea anisata*
(named in honor of Pele (goddess of the Volcano), like anise scented) • Family Name: Rue or Orange (*Rutaceae*)**

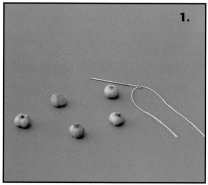

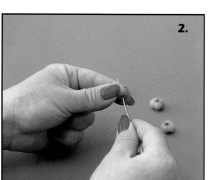

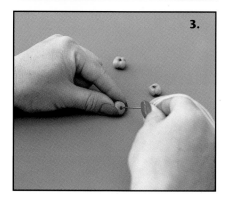

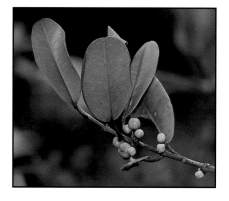

Mokihana **fruit • photo by David S. Boynton**

1. Thread a sewing needle.

2. Pierce the needle through the fruit from the top. Pierce one fruit at a time and pull down to the knotted end of the string. Continue until 40" in length.

3. If fruit is too hard to pierce freely, push needle down through the fruit, toward the table. Be careful. The fruit becomes hard after a few hours from picking. Gloves may be worn to prevent skin irritation.

Description: A tree having anise-scented, 1/2" cube-shaped, leathery fruit. The fruit opens into two parts, holding 2 shiny black seeds in each section. Fruit color changes from green to brown.

Characteristics: The *Mokihana* lei represents the Island of Kaua'i. Direct contact with bare, moist skin may cause a burn or irritation. The lei often serves as a sachet. The Federal Department of Agriculture prohibits the transportation of this fruit to the Mainland. 10-20 days lei life if refrigerated.

Climate/Location: Warm climate; found only in the wild in tropical rainforests on the Island of Kaua'i and the Big Island; direct sunlight.

Season/Harvest Period: May through September. Pick anytime. Fruit should be strung within a few hours of picking to prevent hardening.

Storage: Wrap in damp newspaper. Place in plastic bag or container. Refrigerate.

Materials: Medium grade carpet needle, 52" length 3-ply twine, #10 crochet thread, or dental floss. Thread the carpet needle. Tie a double knot about 6" from one end of the string.

Quantity: 90-112 fruits for a 40" single, *kui pololei,* straight pattern.

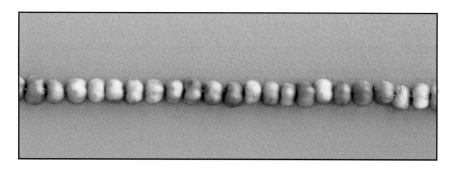

Mokihana **lei:** *kui pololei,* **single lei, straight pattern.**

Nani-O-Ōla'a

Translation: Beauty of Ōla'a (a city near Hilo, Hawai'i) • **Common Name:** Ola'a Beauty or Torenia • **Scientific Name:** *Torenia asiatica* (pretty annual named for Reverend Olof Toren, asian) • **Family Name:** Snapdragon *(Scrophulariaceae)*

Description: A shrub having 1" long dark violet, tubular blossoms with a yellow dotted corolla; no fragrance.

Characteristics: Fragile blossom. One day lei life.

Climate/Location: Warm climate. Grows wild in fields and along roadsides in Ola'a, near Hilo, Hawai'i. Starter plants may be found in local garden shops for backyard cultivation; direct sunlight.

Season/Harvest Period: Year-round, abundant Spring through Summer. Water plants before picking blossoms; pick the blossoms early in the morning. Soak in water for a few minutes for firmness. Drain, then string.

Storage: Keep dry and airtight. Wrap in dry tissue paper. Place in plastic bag or container. Refrigerate.

Materials: Thin, 12" lei needle, 104" length carpet thread, glace finish, cotton covered polyester, folded in half. Tie a double knot about 6" from the open end of the string. Hook on the lei needle.

Quantity: 650 blossoms for a 40" double lei, *kui poepoe*, circular pattern.

Note: Quantities may vary depending on the size of the blossoms.

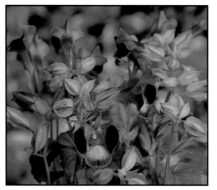

The *Nani-O-Ōla'a* plant

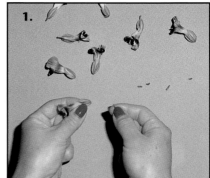

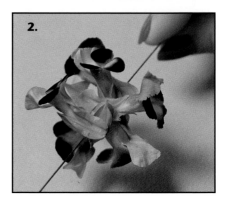

1. Pinch off the blossom stems.

2. Pierce about 21 blossoms, placing 7 in a circular pattern. Gently hold blossoms and pull down to knotted end of string. Continue until lei is 40" long.

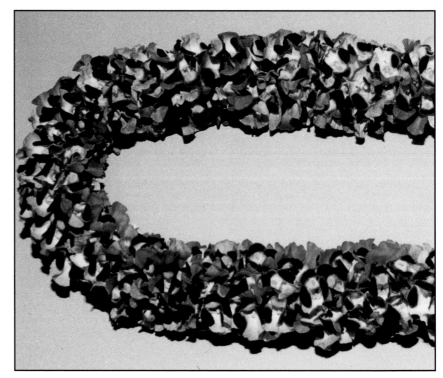

Nani-O-Ōla'a lei: *kui poepoe*, double lei, circular pattern

Nuku-'i'iwi or Ka'i'iwi

Translation: Beak of the 'I'iwi Bird • Common Name: Jade • Scientific Name: *Strongylodon macrobotrys* **(round tooth, with large grape-like clusters) • Family Name: Pea Subfamily** *(Papilionatae)* **or Bean** *(Fabaceae)*

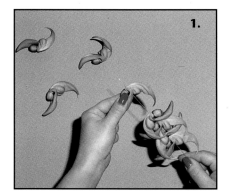

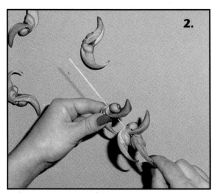

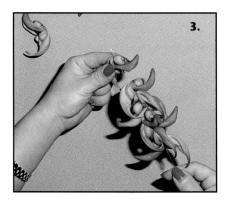

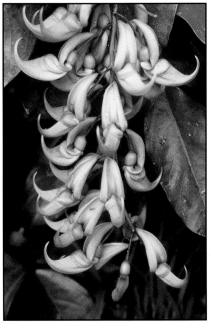

Nuku-'i'iwi blossoms • photo by Heidi Leianuenue Bornhorst

1. Pierce about 6 blossoms in a back-and-forth pattern for a flat lei. Insert the needle from the top of the blossom; do not pierce calyx. Gently hold blossoms and pull down to knotted end of the string. Continue until lei is 40" in length.

2. Pierce 4 blossoms, from the top, in a circular pattern for a double lei.

3. Continue piercing about 12 blossoms. Gently hold the blossoms and pull down to the knotted end of the string. Continue until lei is 40" in length.

Nuku-'i'iwi **leis:** *kui lau,* **flat lei, back-and-forth pattern (top);** *kui poepoe,* **double lei, circular pattern (bottom).**

Description: A vine having blue-green, 3-1/2" long, unusual, horny, pointed blossoms; no fragrance.

Characteristics: Prized for their bluish-green color, very rare in flowers. The seed attached to the base of the blossom may carry microscopic pests. The Federal Department of Agriculture prohibits transporting this flower to the Mainland. Two to 3 days lei life.

Climate/Location: Warm climate; backyard cultivation; filtered sunlight.

Season/Harvest Period: Year-round, low in December and January. Pick blossoms early in the morning, just after they open.

Storage: Sprinkle lightly. Fold or roll. Place in plastic bag or container. Refrigerate.

Materials: Medium, 12" lei needle, 208" length 3-ply lei twine or #10 crochet thread, folded into fourths. Tie a double knot about 6" from the open end of the string. Hook on the lei needle.

Quantity: 95 blossoms for a 40" flat lei, *kui lau,* back-and-forth pattern; 90 blossoms for a 40" double lei, *kui poepoe,* circular pattern.

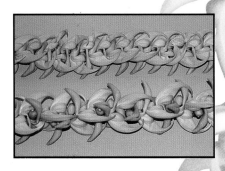

'Ōha'i-Ali'i

Translation: Chief's Poinciana • **Common Name:** Dwarf Poinciana or Pride of Barbados • **Scientific Name:** *Caesalpinia pulcherrima* (ornamental trees and shrubs, named in honor of Andrea Cesalpini, pretty) • **Family Name:** Senna Subfamily *(Caesalpinioideae)* or Bean *(Fabaceae)*

Description: A shrub having red, pink, or yellow feather-like, wispy stamen blossoms, about 2" in length; no fragrance.

Characteristics: The seed at the base of the blossom may carry microscopic insect pests. The Federal Department of Agriculture prohibits transport of this flower to the Mainland. Two to 3 days lei life.

Climate/Location: Tropical, warm climate; backyard cultivation; direct sunlight.

Season/Harvest Period: Year-round, peaking from April through November. Pick blossoms fully openen, in the early morning when cool.

Storage: Sprinkle lightly. Place in plastic bag or container. Refrigerate.

Materials: Thin, 8" lei needle, porous, one-inch thick styrofoam, 52" length 3-ply lei twine or #10 crochet thread. Tie a double knot about 6" from one end of the string. Hook on the lei needle.

Quantity: 350-370 blossoms for a 40" double lei, *kui poepoe,* circular pattern.

'Ōha'i-Ali'i **blossoms**

1. Cut off the blossoms, leaving 1/4" long stems.

2. Pierce about 12 blossoms, placing 4 in a circular pattern. A styrofoam base is used. Gently hold the blossoms and pull down to the knotted end of the string. Continue until lei is 40" in length.

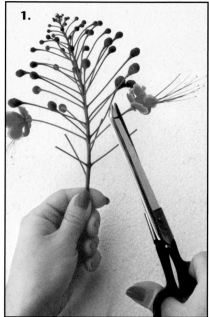

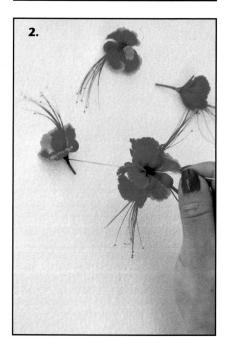

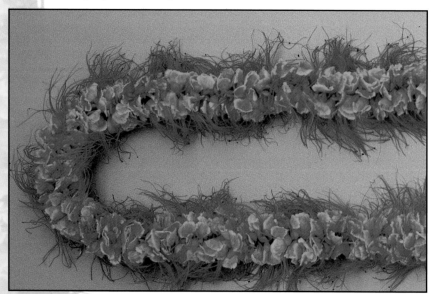

'Ōha'i-Ali'i **lei:** *kui poepoe,* **double lei, circular pattern.**

'Okika (Dendrobium)

Translation: Orchid(Dendrobium) • **Common Name: Dendrobium, Red Soniya, or Thailand Dendrobium**
Scientific Name: *Dendrobium hybrids* (a tree, life) • **Family Name: Orchid (*Orchidaceae*)**

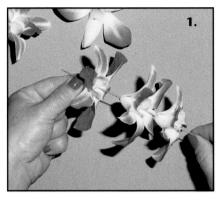

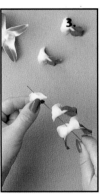

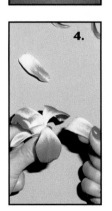

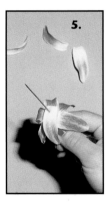

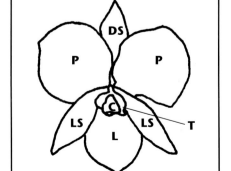

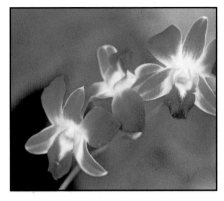

'Okika *(Dendrobium)* blossoms

1. Pierce about 3 blossoms for a single lei; pierce from the nose and through the throat. Gently pull down to knotted end of the string. Continue until 40" long.

2. Pierce about six blossoms, placing 3 in a circular pattern for a double lei. Pierce laterally through backs. Gently pull the blossoms down to the knotted end of the string. Continue until lei is 40" in length.

3. Pierce about 10 blossoms, placing the lips in a back-and-forth pattern for a "Christina" or flat lei. Gently pull the lips down to the knotted end of the string. Continue until the lei is 40" in length.

4. Pull off the top sepal for a double-sepal lei, also known as a "Robyn" lei.

5. Pierce about 35 sepals, placing 7 in a circular pattern. Gently pull sepals down to knotted end of the string. Continue until the lei is 40" long. *Continued on following page*

The parts of a dendrobium orchid:
DS=dorsal sepals, **P**=petals,
C=column or nose, **T**=throat,
LS=lateral sepals, **L**=lip

Description: A stalk-like plant having 2"-3" diameter blossoms with a noticeable lip; similar sepals and petals; light fragrance.

Characteristics: Hardy, long-lasting blossom with a tropical allure; available in white, lavender, purple, green, and brown; popular for shipping to the Mainland. Three to 4 days lei life.

Climate/Location: Tropical, warm climate; backyard cultivation; indirect or direct sunlight.

Season/Harvest Period: Year-round, however some varieties do not blossom in quantity December through February. Pick when blossoms are fully open. Pick when cool.

Storage: Sprinkle lightly. Place in a plastic bag or container. Refrigerate. May be revived by soaking in cold water in the refrigerator for 4 hours. Shake off excess water. Place in a plastic bag. Refrigerate.

Materials: Medium, 12" lei needle, 104" length 3-ply lei twine or #10 crochet thread, folded in half. Tie a double knot about 6" from open end of the string. Hook on the lei needle.

Quantity: 50 blossoms for a 40" single lei, *kui pololei,* straight pattern; 110-120 blossoms for a 40" double lei, *kui poepoe,* circular pattern; 530 blossoms (lips only) for a 40" flat lei, *kui lau,* back-and-forth "Christina" pattern; 1,200 blossoms (dorsal sepals only) for a 40" double-sepal lei, *kui poepoe,* circular "Robyn" pattern; 750-765 blossoms= 1,500-1,530 (petals only) for a 40" double-petal patterned lei; *kui poepoe* circular "Kealii I" pattern; 425 (lips only) for a 40" double-lip lei, *kui poepoe,* circular "Kealii II" pattern.

Note: There are more than 700 varieties of Dendrobium orchids.

6. (Kealii I) Pull off the petals for a double-petal patterned lei; also known as a "Kealii I" lei. Pierce a stack of 10 petals, placing 5 stacks in a circular pattern. Gently pull petals down to the knotted end of the string. Continue until 40" in length.

7. (Kealii II) Pull off the lips for a double-lip lei; also known as a "Kealii II" lei. Fold down the right side of the lip. Pierce 12 lips in a circular pattern. Gently pull lips down to the knotted end of the string. Continue until 40" in length.

*** Leis designed and named by Beth Lopez Garguilo, dedicated to her children.**

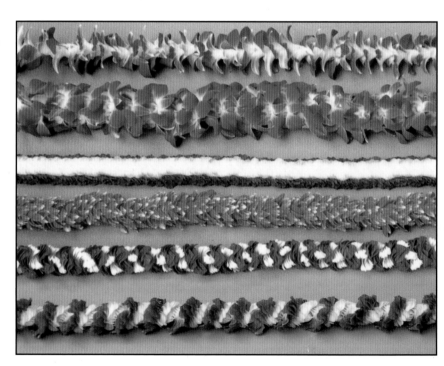

a.

b.

c.*

d.*

e.*

f.*

'Okika leis: a. *kui pololei,* single lei, straight pattern; b. *kui poepoe,* double lei, circular pattern; c. *kui lau,* flat lei "Christina," back-and-forth pattern; d. *kui poepoe,* double-sepal "Robyn" lei, circular pattern; e. *kui poepoe,* double petal pattern lei, "Kealii I," circular pattern; f. *kui poepoe,* double lip lei "Kealii II," circular pattern.

'Okika (Epidendrum)

Translation: Orchid(Epidendrum) • **Common Name:** Epidendrum, Epis, or Baby Orchid • **Scientific Name:** *Epidendrum Phoenicium* (upon a tree, epiphytic or tree-perching orchids) • **Family Name:** Orchid *(Orchidaceae)*

'Okika (Epidendrum) blossoms

1. Pinch off the stems, leaving 1/4."

2. Pierce about 12 blossoms, placing 3 in a circular pattern, for a double lei. Gently hold the blossoms and pull down to the knotted end of the string. Continue until lei is 40" in length.

Description: A grass-like stemmed plant having numerous clustered, purplish blossoms; no fragrance.

Characteristics: Epis come in a variety of colors. Two to 3 days lei life.

Climate/Location: Warm climate; backyard cultivation; direct sunlight.

Season/Harvest Period: Year-round, peaking in the Spring through Summer. Pick blossoms when they are fully opened. Pick when cool.

Storage: Sprinkle lightly. Refrigerate.

Materials: Thin, 8" lei needle, 52" length carpet thread, glace finish, cotton covered polyester. Tie a double knot about 6" from one end of the string. Hook on the lei needle.

Quantity: 370-400 blossoms for a 40" double lei, *kui poepoe,* circular pattern.

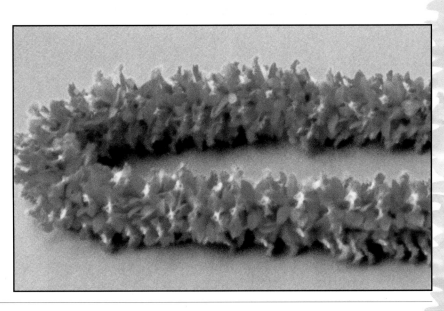

'Okika (Epidendrum) lei: *kui poepoe,* double lei, circular pattern.

'Okika (Vanda)

Translation: Orchid (Vanda) • **Common Name:** Vanda, Miss Joaquim, or Vanda Orchid • **Scientific Name:** *Vanda "Miss Joaquim"* (Hindi name for one epiphytic orchid, named after Miss Joaquim) • **Family Name:** Orchid (*Orchidaceae*)

Description: An erect vine having purplish, 2-1/2" diameter blossoms with a noticeable lobed lip, 3 rounded lavender petals, and 2 rounded white sepals; mild fragrance.

Characteristics: Strong and durable; popular for shipping to the Mainland. Four to 5 days lei life.

Climate/Location: Warm to cool climate; backyard cultivation; direct sunlight.

Season/Harvest Period: Year-round, peaking in the Summer. Pick blossoms in the evening or early morning when it is cool.

Storage: Sprinkle well. Wrap in damp newspaper or paper towel. Store in a paper box. Flowers may turn white if kept airtight. Refrigerate. May be revived by soaking in cold water in the refrigerator for 4 hours. Shake off excess water. Place in a plastic bag. Refrigerate.

Materials: Thick, 12" lei needle, 104" length 3-ply lei twine or #10 crochet thread, folded in half. Tie a double knot about 6" from the open end of the string. Hook on the lei needle.

Quantity: 50 blossoms for a 40" single lei, *kui pololei,* straight pattern; 125 blossoms for a 40" double lei, *kui poepoe,* circular pattern; 250 blossoms for a 40" half-Maunaloa lei, *kui pololei,* straight pattern; 230 blossoms for a 40" Maunaloa lei, *kui lau,* back-and-forth pattern.; 300 blossoms for a 40" petal lei; *kui poepoe,* circular pattern.

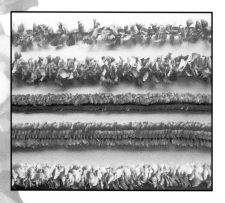

'**Okika (Vanda) blossoms**

1. Pull off the 2 white sepals. Pinch off the stems.

2. Pierce about 4 blossoms through the nose and throat for a single lei. Gently pull blossoms down to knotted end of string. Continue until lei is 40" in length.

3. Pierce 6 blossoms, placing 3 in a circular pattern for a double lei. Pierce the back of blossom, near stem mark, through the nose. Gently pull down to the knotted end of the string.

4. Break off the "lip" of the blossom.

5. Pierce 9 lips in a straight pattern through the throat for a one-sided flat Maunaloa lei. Gently pull blossoms down to the knotted end of the string. Continue until the lei is 40" long.

6. Pierce 9 lips through the throat in a back-and-forth pattern. Gently pull blossoms down to knotted end of string. Continue until the lei is 40" long.

7. Break off lips and stems. Pierce about 15 blossoms, placing 3 in a circular pattern for a petal lei. Gently pull blossoms down to the knotted end of string. Continue until lei is 40" long.

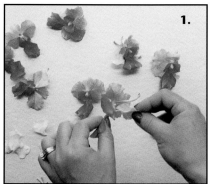

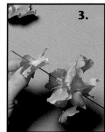

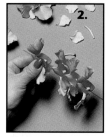

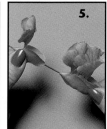

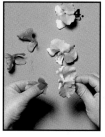

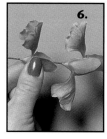

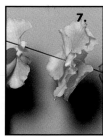

'**Okika (Vanda) leis:**
kui pololei, **single lei, straight pattern;** *kui poepoe,* **double lei, circular pattern;** *kui pololei,* **one-sided, flat Moanaloa lei, straight pattern;** *kui lau,* **flat Moanaloa lei, back-and-forth pattern;** *kui poepoe,* **double petal lei, circular pattern**

Pahūpahū

Translation: Firecracker • Common Name: Firecracker, Flame Vine, or Firecracker Vine
Scientific Name: *Pyrostegia venusta* (fire, charming) • Family Name: Bignonia (*Bignoniaceae*)

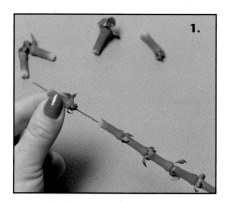

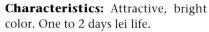

A *Pahūpahū* vine

1. Pierce about 5 blossoms for a single lei. Gently hold the blossoms and pull down to the knotted end of the string. Continue until lei is 40" in length.

2. Pierce about 20 blossoms laterally, placing 3 in a circular pattern, for a double lei. Gently hold the blossoms and pull down to the knotted end of the string. Continue until lei is 40" in length.

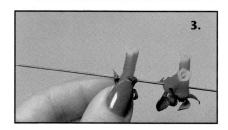

3. Pierce about 20 blossoms laterally, placing 2 in a "V" pattern. Gently hold the blossoms and pull down to the knotted end of the string. Continue until the lei is 40" in length.

Description: A vine having 1" long bright red, slender, fuzzy blossoms; no fragrance.

Characteristics: Attractive, bright color. One to 2 days lei life.

Climate/Location: Tropical climate; backyard cultivation; direct sunlight.

Season/Harvest Period: Year-round. Pick blossoms early in the morning or evening when cool.

Storage: Keep dry. Place in plastic bag or container. Refrigerate.

Materials: Medium, 12" lei needle, 104" length 3-ply lei twine or #10 crochet thread, folded in half. Tie a double knot about 6" from the open end of the string. Hook on the lei needle. 208" length thread folded into fourths recommended for a "V" lei.

Quantity: 65 blossoms for a 40" single lei, *kui pololei*, straight pattern; 450 blossoms for a 40" double lei, *kui poepoe*, circular pattern; 450 blossoms for a 40" "V" lei, *kui lau*, back-and-forth pattern.

Pahūpahū leis: *kui pololei*, single lei, straight pattern (top); *kui poepoe*, double lei, circular pattern (middle); *kui lau*, "V" lei, back-and-forth pattern (bottom).

Pā'ina

Translation: Pine trees of all kinds, cone-bearing trees • **Common Name:** Ironwood, Warrior Tree, She Oak, Beefwood Oak, or Toa • **Scientific Name:** *Casuarina equisetifolia* (branches resemble feathers of a cassowary, with leaves like a horsetail) • **Family Name:** Casuarina *(Casuarinaceae)*

Description: A tree having miniature pine cones about 3/4" to 1" long. Young pine cones are green, then mature to brown.

Characteristics: Some believe this tree symbolizes "faithfulness." Ever-lasting lei life.

Climate/Location: Warm climate; near the shoreline; direct sunlight.

Season/Harvest Period: Year-round. Pick dried cones that have fallen to the ground.

Storage: Keep dry. Store at room temperature.

Materials: Rotary drill with a 1/16" bit; nail clippers; 104" length #10 crochet thread, folded in half. Almost any needle will work for stringing this lei. Tie a double knot about 6" from the open end of the string. Hook on the lei needle.

Quantity: 50-55 cones for a 40" single lei, *kui pololei,* straight pattern.

Note: Before stringing cones, they should be washed, dried, and placed in a freezer for at least 3 days to remove any insect pests that may have inhabited the cones. This tree is often mistaken for a pine tree.

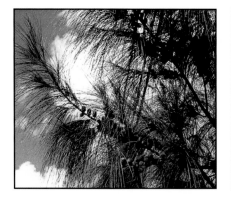
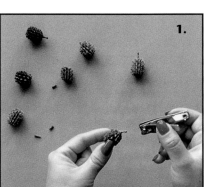

A *Pā'ina* tree. Dried *Pā'ina* cones on the ground.

1. Cut off stems with a nail clipper.

2. Drill a hole through the cone, using a 1/16" drill bit. Start at the base.

3. Pierce about 5 cones. Grasp all cones and pull down to the knotted end of the string. Continue until lei is 40" in length.

Pā'ina leis: *kui pololei,* **single lei, straight pattern (top);** *kui pololei wili,* **single lei, straight pattern, twined with 3 strands (bottom).**

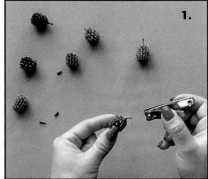

1.

2.

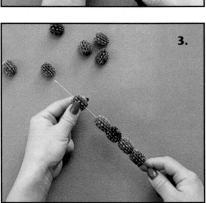

3.

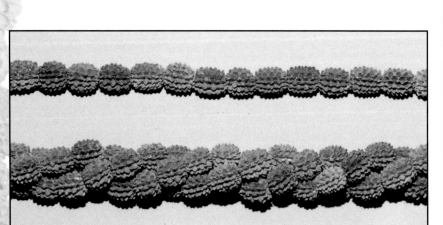

Pakalana

Translation: Paklan • Common Name: Chinese Violet • Scientific Name: *Telosma cordata*
(far fragrance, heart-shaped) • Family Name: Milkweed or Crownflower (*Asclepiadaceae*)

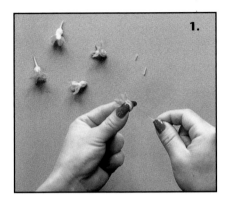

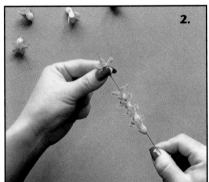

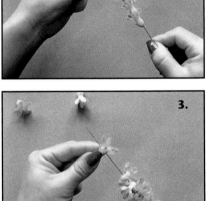

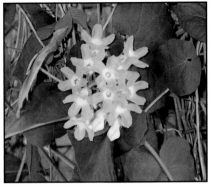

A *Pakalana* vine

1. Pinch off stems.

2. Pierce about 5 blossoms for a single lei. Gently hold blossoms and pull down to knotted end of the string. Continue until 40" in length.

3. Pierce about 12 blossoms, placing 3 in a circular pattern, for a double lei. Pierce blossoms laterally. Gently hold blossoms and pull down to knotted end of string. Continue until 40" in length.

Description: A vine having 1" long, tubular, yellowish-green, five-part blossoms; strong fragrance.

Characteristics: Lei associated with "love." One to 2 days lei life.

Climate/Location: Tropical, warm climate; backyard cultivation; grown on a fence or trellis; direct sunlight.

Season/Harvest Period: Abundant May through October. Pick blossoms early in the morning when cool. Place in plastic container until enough blossoms have been collected. Refrigerate.

Storage: Sprinkle. Place in a damp paper towel. Store in a plastic bag or container. Refrigerate. May be revived by soaking in cold water in the refrigerator for 4 hours. Shake off excess water. Place in a plastic bag. Refrigerate.

Materials: Medium 12" lei needle, 52" length 3-ply lei twine or #10 crochet thread. Tie a double knot about 6" from one end of the string. Hook on the lei needle.

Quantity: 125-150 blossoms for a 40" single lei, *kui pololei*, straight pattern; 240-260 blossoms for a 40" double lei, *kui poepoe*, circular pattern.

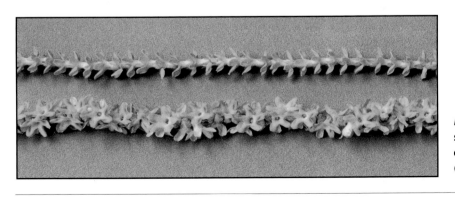

***Pakalana* leis: *kui pololei*, single lei, straight pattern (top); *kui poepoe*, double lei, circular pattern (bottom).**

Pīkake

Translation: Peacock • **Common Name:** Arabian Jasmine or Sampaguita • **Scientific Name:** *Jasminum sambac* (Persian for yasmin, sweet scented shrub and climbers, Zambac Persian name for Jasmine) • **Family Name: Olive** *(Oleaceae)*

Description: A shrub having small, white, tubular, pearl-like, 3/4" long buds. The fully-open flowers are about 1" in diameter; 5-9 petals; intensely fragrant.

Characteristics: Popular wedding flower lei in Hawai'i. The buds start to blossom immediately when not refrigerated. One day lei life.

Climate/Location: Tropical, hot, dry climate; low elevation; backyard cultivation; direct sunlight.

Season/Harvest Period: Year-round. Low in the months of December through February. Pick early in the morning as buds. Place in a sealed glass jar. Refrigerate until enough buds have been collected.

Storage: Keep dry. Coil up in a flat, spiral pattern. Wrap in waxed paper. Refrigerate.

Materials: Medium 12" lei needle, 104" length 3-ply lei twine or #10 crochet thread, folded in half. Tie a double knot about 6" from the open end of the string. Hook on the lei needle.

Quantity: 90-105 blossoms for a 40" single lei, *kui pololei*, straight pattern; 530-630 blossoms for a 40" small double lei, 25 cent coin size, *kui poepoe*, circular pattern; 800-900 blossoms for a 40" medium double lei, 50 cent coin size, *kui poepoe*, circular pattern; 950-1,000 blossoms for a 40" large double lei, silver dollar coin size, *kui poepoe*, circular pattern.

Note: Quantities may vary depending on the size of the blossoms.

A *Pīkake* plant

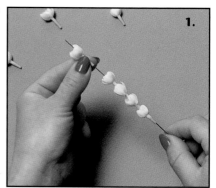

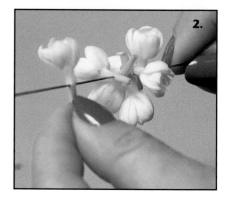

1. Pierce about 5 blossoms for a single lei. Gently hold blossoms and pull down to the knotted end of the string. Continue until lei is 40" in length.

2. Pierce about 50 blossoms, placing 4 in a circular pattern, for a double lei, or a small rope lei. Place 6 in a circular pattern for a double lei, or medium rope lei. Place 7 in a circular pattern for a double lei, or large rope lei. Gently hold blossoms and pull down to the knotted end of the string. Continue until lei is 40" in length.

Pīkake leis (top to bottom): *kui pololei*, single lei, straight pattern; *kui poepoe*, small double or small rope, circular pattern; *kui poepoe*, medium double lei or medium rope, circular pattern; *kui poepoe*, large double lei or large rope, circular pattern.

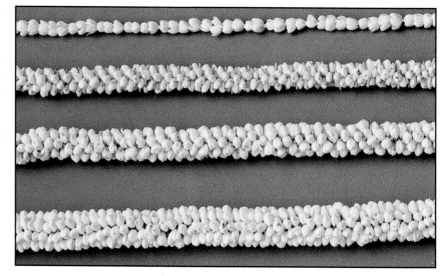

Poni-Mo'i

**Translation: Coronation • Common Name: Carnation • Scientific Name: *Dianthus caryophyllus*
(Zeus flower, smell of walnut leaves) • Family Name: Pink (*Caryophyllaceae*)**

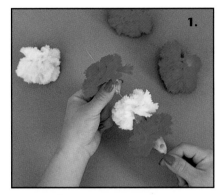

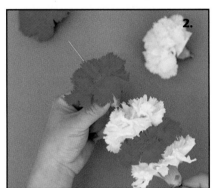

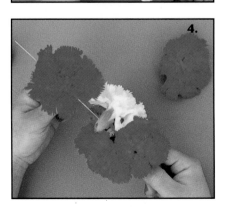

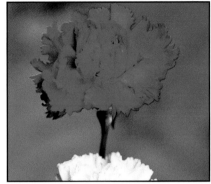

Poni-Mo'i blossoms

1. Pierce about 3 blossoms for a semi-single lei. Gently hold blossoms and pull down to the knotted end of the string. Continue until lei is 40" in length.

2. Pierce about 4 blossoms for a single lei. String blossoms close together, covering the calyx. Gently pull blossoms down to the knotted end of the string. Continue until lei is 40" in length.

3. Break calyx into fourths. Pierce about 5 blossoms for a full single lei. Gently pull blossoms down to knotted end of string. Continue until 40" long. (Often called a "double" lei.)

4. Pierce 6 blossoms, placing 3 in a circular pattern for double lei. Gently pull blossoms down to knotted end of string. Continue until 40" long. (Often called a "triple" lei.)

Poni-Mo'i leis: Kui pololei, semi-single, straight pattern; Kui pololei, single lei, straight pattern; Kui pololei, full single or "double" lei, straight pattern; Kui poepoe, double or "triple" lei, circular, double pattern

Description: A plant having 2" diameter blossoms with 30 or more petals forming a rounded head; edges are toothed; cylindrical calyx is 5-toothed; mild fragrance.

Characteristics: A popular lei for graduation. Two to 3 days lei life.

Climate/Location: Cool, upland climate; backyard cultivation; direct sunlight.

Season/Harvest Period: Year-round; low during December through February. Pick blossoms early in the morning when cool.

Storage: Sprinkle well. Gently shake off excess water. Wrap in a damp paper towel. Store in a plastic bag. Refrigerate. Shake off excess water before wearing lei.

Materials: Thick 12"-16" lei needle, 104" length 3-ply lei twine or #10 crochet thread folded in half. Tie a double knot about 6" from the open end of the string. Hook on the lei needle.

Quantity: 25-30 blossoms for a 40" semi-single lei, *kui pololei*, straight pattern; 40-50 blossoms for a 40" single lei, *kui pololei*, straight pattern; 60-70 blossoms for a 40" full single or "double" lei, *kui pololei*, straight pattern; 75-85 blossoms for a 40" double style or "triple" lei, *kui poepoe*, circular, double pattern.

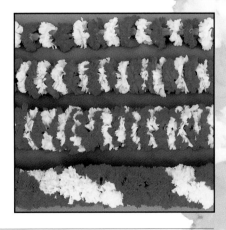

Lei Restrictions

The Federal Department of Agriculture will not allow leis made from the following flowers, foliage, fruits, and berries to enter the U.S. Mainland:

- Hala - Screw Pine
 Pandanus odoratissimus

- Hinahina 'Umi 'Umi O Dole - Spanish Moss
 Tillandsia usneoides

- Kai Waina - Sea Grape
 Coccoloba uvifera

- Kakia - Cassia or Candle Bush
 Cassia alata

- Kauhi - True Maunaloa
 Canavalia microcarpa

- Kauna'oa - Dodder
 Cuscuta sandwichiana

- Kiele - Gardenia
 Gardenia jasminoides

- Kiele (Tiare) - Tahitian Gardenia
 Gardenia taitensis

- Kikanea - Solanum
 Solanum aculeatissimum

- Loke - Rose with Leaves
 Rosa damascena

- Loke Lau - Green Rose
 Rosa chinensis var. viridiflora

- Maile (if insect pests are visible)
 Alyxia olivaeformis

- Mokihana
 Pelea anisata

- Nuku'i'iwi - Jade
 Strongylodon macrobotrys

- 'Ohai Ali'i - Royal Monkeypod
 Caesalpina pulcherrima

- All "Pea subfamily"-
 any part of the plant

- All berries and fruits

For more information, call The O'ahu Plant Quarantine Branch at 808/586-0844. The listing is subject to change.

Bibliography

Bird, Arden J., and Josephine Puninani Kanekoa Bird. *Hawaiian Flower Lei Making*. Honolulu: University of Hawaii Press, 1987.

Clay, Horace F., and Hubbard, James C. *The Hawaii Garden Tropical Shrubs*. Honolulu: University of Hawaii Press. 1977.

Clay, Horace F., and Hubbard, James C. *The Hawaii Garden Tropical Exotics*. Honolulu: University of Hawaii Press, 1977.

Coombs, Allen J. *Dictionary of Plant Names*. Portland, Oregon: Timber Press, 1985.

Hargreaves, Dorothy. *Tropical Blossoms of the Pacific*. Honolulu: Hargreaves Co., 1970.

Kuck, Loraine E. *Hawaiian Flowers and Flowering Trees*. Ruthland,

Vermont: E. Tuttle Company, Inc., 1958.

Kuck, Loraine E. *The Story of the Lei*. Honolulu: Tongg Publishing Co., 1983.

McDonald, Marie A. *Ka Lei: The Leis of Hawaii*. Honolulu: Press Pacifica, 1989.

Moir, May A. *The Garden Watcher, Revised Edition*. Honolulu: University of Hawaii Press, Bishop Museum Press, 1989.

Neal, Bill. *Gardener's Latin*. Chapel Hill, NOrth Carolina: Algonquin ooks of Chapel Hill; a division of Workman Publishing company, Inc., 1992.

Neal, Marie C. *In Gardens of Hawaii*. Honolulu: Bishop Museum Press, 1965.

Pukui, Mary Kawena, and Elbert, Samuel H. *Hawaiian Dictionary, Revised and Enlarged Edition*. Honolulu: University of Hawaii Press, 1986.

Shirkey, Wade. *Memory of child lives in lei that people adore. The Honolulu Advertiser*, May 1, 1998. p.A-1, A-4.

Smith, A.W. *A Gardener's Dictionary of Plant Names*. New York: St. Martin's Press, 1972.

Wagner, Warren L., Herbst, Derral R., and Sohmer, S.H. *Manual of the Flowering Plants of Hawaii, Volume I*. Honolulu: University of Hawaii Press, Bishop Museum Press, 1990.

Wagner, Warren L., Herbst, Derral R., and Sohmer, S.H. *Manual of the Flowering Plants of Hawaii, Volume II*. Honolulu: University of Hawaii Press, Bishop Museum Press, 1990.